pur
Web F

KF

Collins

YOU CAN PAINT

Sketch

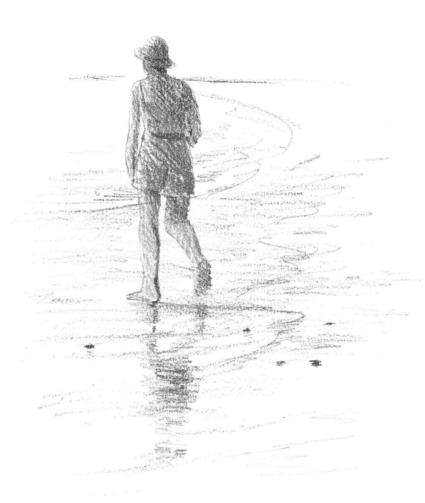

JACKIE SIMMONDS started painting in her thirties, attending art
school as a full-time 'mature student', and is now a busy
painter and art instruction author. She exhibits her original
works regularly at the Linda Blackstone Gallery in London, and
other galleries throughout the UK, and reproductions of her
work are sold worldwide. An excellent communicator, Jackie
writes for *The Artist* magazine, and runs occasional workshops
and painting holidays. She has also made six art instruction
videos, and this is her fourth book.

YOU CAN PAINT

Sketch

A step-by-step guide for
ABSOLUTE BEGINNERS

JACKIE SIMMONDS

First published in 2001 by
Collins, an imprint of
HarperCollins*Publishers*
77-85 Fulham Palace Road
Hammersmith
London W6 8JB

Collins is a registered trademark of
HarperCollins Publishers Limited

The Collins website address is
www.**collins**.co.uk

04 06 07 05 03
4 6 8 9 7 5

**A catalogue record of this book is available from the
British Library**

Editor: Isobel Smales
Designer: Penny Dawes
Photography: Laura Knox

ISBN 0 00 413400 1

Colour reproduction by Colourscan, Singapore
Printed and bound by Rotolito Lombarda SpA, Italy

CONTENTS

INTRODUCTION

As a child, I am sure you revelled in the business of making marks. Even tiny tots love to grab a pencil or crayon, and will scribble away with intense pleasure for ages. Of course, children are completely uninhibited and, in their innocence, will be delighted with the results they achieve, whatever these look like. As adults, our inhibitions grow, and we often fell embarrassed by less than perfect results, particularly when encouraged to show our efforts to others. This book will, I hope, encourage you to have a go, regardless of any lack of experience, in order to rediscover the sheer joy to be gained from sketching.

Learning to sketch is great fun, and although the word 'learning' implies a duty, it is important to remember that learning can be exciting, challenging and, most importantly,

very rewarding. Gradually, your confidence will grow, and tentative beginnings will very soon develop into positive results. Best of all, you don't need to be an expert draughtsperson to enjoy sketching – absolute accuracy is not essential in most sketches, and often the unfinished quality of a sketch adds to its appeal.

When you make a sketch, you are not necessarily producing a work that will find

These sheep were sketched with watersoluble art pens

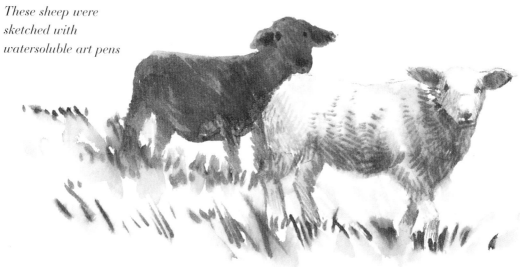

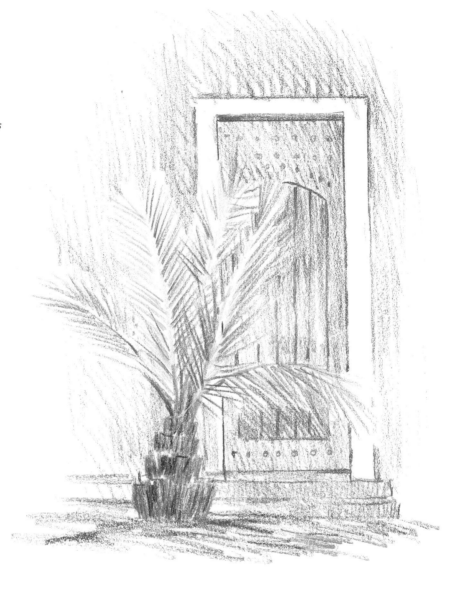

This sketch of a doorway was done with coloured pencils

its way onto the walls of an art gallery. Sketches can be made to collect information. to explore possible subjects for later pictures. or can be made just for fun. What matters is that with every sketch you do, you learn something about drawing and improve your eye/hand co-ordination skills and powers of observation. and this will help you to establish a firm foundation from which you will be able to grow as a creative individual.

Look upon this book as a source of help and information. while you practise and develop your sketching language. You can keep your sketchbooks totally private – they should be, after all. working exercise books. Nurture your budding talent gently, and only when you feel ready do you need to show others the results of your efforts. That may be sooner than you think. provided you get stuck in with a positive attitude and practise. practise. practise!

HOW TO USE THIS BOOK

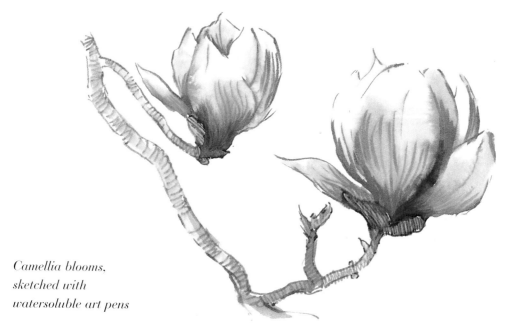

This is an art instruction book for beginners, containing a large variety of examples, exercises and demonstrations. However, what it does not contain is reams of text. As a teacher, I have come to realise that students – of every age – are keen to get going, and although written, or verbal, explanation is obviously useful, there is nothing quite like the physical act of doing a sketch oneself, or watching a teacher. Every page of this book offers you an example of a sketch, and each exercise is simply and clearly explained, and broken down into simple steps which are easy for you to follow. By all means

copy my examples, but once you have tried out an exercise, and become familiar with the techniques explained, I suggest you find a similar object, or subject, and work from life, using the principles I have shown you.

You will notice that I have not been specific about the 'names' of the colours I have used. This is because there are many different manufacturers of art materials on the market, and each manufacturer uses slightly different names. Don't worry about this at all; simply use a colour which is similar to the one I have used; this will be fine.

The exercises and examples are fairly short and straightforward. In some of the chapters,

*Camellia blooms,
sketched with
watersoluble art pens*

*A mixed media sketch,
done with brush pen
and pastel pencils*

you will find a slightly longer demonstration
piece, broken down into several more steps for
you to follow.

Throughout the book, I have used a variety
of sketching tools to enable you to become
familiar with different materials. You may
like some materials, and some subjects,
better than others; this is fine – it is important
to discover what you like to draw, and what
you like to draw with. Keep an open mind,
and be prepared to try everything.

As you practise, your own style will
gradually emerge. Work in a sketchbook, and I
promise you that by the time you have filled
your sketchbook, your fluency and skill will
have improved immeasurably. By the time you
have filled five sketchbooks, there will be no
stopping you!

BASIC MATERIALS

You will find all sorts of different drawing media in your art materials shop, and although no one drawing medium is superior to any other, I believe it is fair to say that some are more popular than others, such as the familiar lead pencil, charcoal and conté sticks, because they have proved their versatility over the years. It is only by trial and error – or perhaps trial and success – that you will discover what suits you best.

I have used a fairly limited range of drawing materials in this book; these are my favourite ones. Some are traditional and some are the more modern, innovative materials on the market, such as watersoluble pencils and art brush pens, which have a firm point at one end, just like a fibre-tip pen, and a softer, brush-like tip at the other end.

I believe that the selection is varied enough for you to enjoy discovering a fascinating range of sketching possibilities. Once you are familiar with the materials that I suggest, you can go on to try a variety of others, as the mood takes you.

Sketching equipment can be simple and very lightweight.

Here are the sketching implements used in this book, as listed below, together with the marks they make.

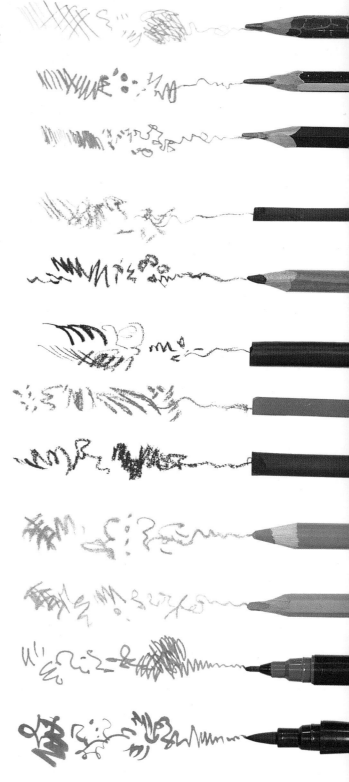

Suggested materials

My chosen drawing materials are:

Lead pencils I recommend grades HB (medium hard), 2B (soft) and 4B (very soft). Always buy good quality (more expensive) pencils, since the better quality pencils have the lead bonded to the wooden case of the pencil to prevent breakage of the lead if you drop the pencil. It is most frustrating to try to sharpen a pencil only to discover that the lead is broken all the way to the bottom. Ask for advice at your art materials shop if you are not sure which manufacturer's products to choose.

Charcoal sticks These are available in various sizes. It is probably best to buy a mixed box.

Compressed charcoal in pencil form This is useful for more detailed work.

Conté This is available as both sticks and pencils.

Pastel pencils These are thin sticks of hard pastel in pencil form.

Coloured pencils These are clean and portable.

Watersoluble coloured pencils The marks can be dissolved to give a watercolour wash effect.

Art brush pens These are pens with a fine tip at one end and a brush at the other.

A selection of the author's sketchbooks, complete with sketches.

Sketchbooks The variety of sketchbooks on the market can be bewildering. However, it's a good idea to have a selection of sketchbooks of different sizes, from pocket-size to large. Also, it's good to try different surfaces. You will quickly discover that sketches on cartridge paper, which is quite smooth, look very different from sketches on watercolour paper, which is often textured. A sketchbook with coloured paper pages makes an interesting and challenging change from white paper.

I recommend that you make sure your sketchbooks have good, solid covers which will stand up to wear and tear. Also, if you plan to use watersoluble implements, it is sensible to use heavier papers, either a thick cartridge paper or watercolour paper, since thin, lightweight papers will buckle when you add water. Spiral binding can be useful; if you like to work on one page you can turn the rest back. If the book has a firm binding, don't be afraid to work across the centre if you want to create a large drawing.

You will also need:

An eraser A putty eraser is best for charcoal, and a firmer, plastic eraser best for pencil.

A craft knife This is useful for sharpening pencils.

Fixative This is a spray used to prevent drawings from smudging.

Bulldog clips These are very useful when working out of doors in windy weather, to keep your sketchbook open.

A sturdy pencil case I use a hinged, metal spectacles case.

A torchon This is a rolled paper stump, used for blending charcoal or conté.

Optional extras:

A fine sandpaper block This is used to create a sharp point on a pencil or a piece of charcoal.

A sketching easel This is useful if you prefer not to work with your sketchbook on your knee.

A lightweight sketching stool This is very useful out of doors. I recommend one with a back rest.

A long stick for measuring A smallish plant stake is ideal.

A bag You will need a bag to carry your equipment.

These are some of the extra items that you will find useful.

MAKING MARKS

One of the best ways to learn about your materials is to analyse what they can do by making marks. I suggest that you produce practice sheets like mine, beginning with that most familiar of objects, the lead pencil. Don't expect your results to be identical to mine; everyone has their own personal handwriting.

Graphite lead pencils

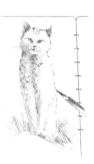

Lead pencils are graded – those with an 'H' designation are harder than those with a 'B' – thus 2B is soft, 6B even softer; 2H is hard and 6H is very hard. The softer the pencil, the blacker the mark. I suggest you try HB, 2B and 4B pencils.

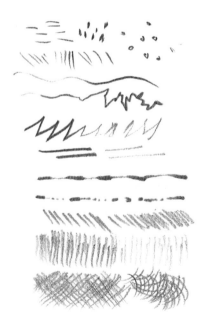

To create an area of interesting texture, scribble with the point of a pencil, and then use an eraser to soften lines and remove areas.

Using the point of the pencil, try creating lots of lines. Vary the pressure on your pencil, and always keep the point long and sharp. Develop some parallel lines into areas of shading, to create 'tone'. Then criss-cross some lines in different directions – called 'cross-hatching'.

Sharpen the pencil to a long point, and create an area of 'tone' by using it on its side. Hold the pencil cupped in the palm of your hand, with your fingers downwards and the back of your hand facing upwards. Add more graphite to the base of the shape as you work.

Charcoal

Charcoal is wonderfully versatile, and easy to correct, so is perfect for the beginner. In stick form it is particularly good used in a loose, sketchy way which doesn't involve too much detail, and compressed charcoal sticks can be sharpened for detailed work. Charcoal work needs a spray of fixative to stop it from smudging.

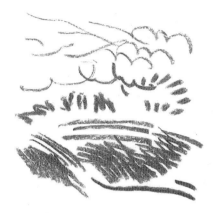

Make some lines with a thin stick of charcoal, and try some cross-hatching too. If you turn the stick in your fingers as you work, you can maintain a point. Try this with a charcoal pencil, to see how different it feels.

Use the side of a stick pressed against the paper to cover an area of paper – thicker sticks are easier to hold. Try using different types of paper to see the effects – watercolour paper will break up the marks far more than smooth paper.

Scribble some lines with the point of the charcoal, and then blend, or smudge, with a finger. This is a useful technique to master for lovely soft effects, with no hard edges or texture.

Use charcoal on its side for a dense area of tone, and then lift out light areas with a piece of putty eraser. If you squeeze the putty eraser into a point, you can also lift out fine lines.

Conté

Conté, either in stick or pencil form, behaves much like charcoal, but it is harder.
Nevertheless, it is still possible to blend colours by rubbing with a finger, or a rolled paper stump
(called a 'torchon'). Conté is less 'sooty' than charcoal, and colours can be mixed by laying one
colour over another. Conté comes in a variety of colours, but my favourites are the traditional
black, white and earth colours – sepia (dark brown), sanguine (terracotta) and bistre (brown).
In stick form it can be sharpened to a point, or used on its side for blocking-in larger areas.

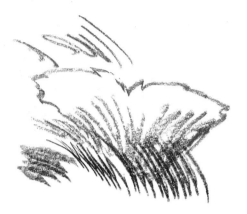

*Use one of the brown earth tones, together with
a black conté stick or pencil, to try out linear
marks. Work freely and swiftly.*

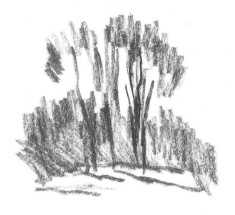

*Now try sanguine, which is a lovely warm red.
Vary the pressure as you work – your marks
will be darker where you press harder.*

*Break a small piece from a stick of conté, and
use it on its side, twisting your wrist as you
work. The texture you achieve will depend on
the paper you use, so may differ from mine.*

*Use the conté on its side, then smudge with a
finger. Scribble on top with a darker tone, then
try some white lines over the top. If you 'fix' it
before using white, the lines may be clearer.*

Pastel pencils

Pastel pencils are essentially thin sticks of hard pastel in pencil form. Unlike ordinary sticks of pastel, the pencils are clean to use, and won't break or crumble. They are excellent for colour sketches, but will need a spray of fixative to prevent them from smudging. You can use them in white sketchbooks, but it's also fun to try them on coloured paper, so that you can use a white pencil as well as coloured ones.

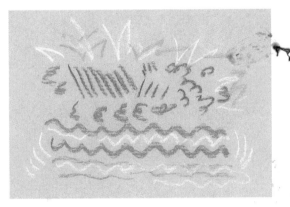

Using colours of your own choice, make a variety of lines, dots, and stabbing marks, being conscious of the pressure you use and the effect as a result.

Now lay lines over each other to create a denser, more textured effect. Build up the area gradually, leaving some paper showing between strokes.

Using three different colours, make three strips of lines, and then blend lightly with a finger. Blending will create a soft, diffused effect, much like a watercolour 'wash'.

Blend two or three different blues together, and then make some lines over the top. Finally, finish off with white and blue dots, or any marks which appeal to you.

Coloured pencils

Coloured wax pencils will, I'm sure, feel quite familiar to you – we all used them as children. They are clean and portable, and available in a wide range of colours. They allow you to create areas of delicate colour as well as fine detail. Always sharpen your pencils to a long point, and as you work, practise rotating the pencil in your fingers to keep the point nice and sharp. Rather than pressing hard to achieve dense layers of colour, which can make the surface slick and greasy, it is generally better to build up layers gently, allowing the white paper to 'illuminate' the layers.

Using one pencil, build up the colour gradually, with a series of layers, creating an area of tone.

Try two different colours, and see how they create the illusion of a third colour where they mix together.

Now try two or three colours from the same 'family' of colours, blues perhaps, or oranges. Leave gaps of white paper to add sparkle. Areas of colour created by using several similar colours have a very lively and exciting feel.

Sharpen a pencil to a long point and, holding the pencil at its far end, scribble down an area of colour – I used my purple first. Then try adding fine detail in lots of colours over the top.

Watersoluble coloured pencils

These are a wonderful modern medium, which extend the versatility of coloured pencils dramatically. Marks can be dissolved with a brush, sponge, or even a wet finger, to create fascinating watercolour-wash effects. Then, when the paper is dry again, you can add more marks and areas of colour. It is best to use watercolour paper, or heavy cartridge paper. Please *don't* dip the pencil into water: dampen the tip with the end of a wet brush for softer marks.

Make simple lines, then dissolve them into a puddle of water.

Shade two colours together, and then dissolve with water, to see how a third colour is created.

Scribble an area of colour. On the left hand side, drop down a very wet puddle, and on the right hand side, use an almost dry brush to loosen the colour. See how the effects differ.

Wet the paper first, and while it is runny-wet, make some marks and see how they soften and dissolve slightly.

Wet the paper, and drop tiny pencil shavings cut with your craft knife down into the wet area. Firmer shavings will look like little curls of colour. My 'bricks' were drawn with a pencil, then wetted, and then colour was shaved into them for a lovely textured effect.

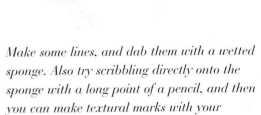

Make some lines, and dab them with a wetted sponge. Also try scribbling directly onto the sponge with a long point of a pencil, and then you can make textural marks with your sponge – great for foliage.

Pens

Fibre-tip, felt-tip and marker pens are available in a wide variety of types and colours, and you will need to try various types to see which you prefer. For these illustrations, I have chosen watersoluble art pens which have a fine firm point at one end, and a useful flexible brush tip at the other end. You can buy similar, waterproof ones, which are spirit- or alcohol-based. These are perhaps a little better for overlaying colours, but they do have a tendency to 'bleed through' the pages of cartridge paper sketchbooks.

The firm point of the art pen is excellent for lively drawing, but there is little variety in the line.

Try some 'feathering' – lines laid down side by side. Notice the dark tone where the rows overlap. Leaving some white paper adds sparkle.

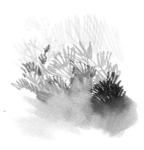

Try different colours and shades together, and use scribble and cross-hatching. Float a little water over the bottom and see the ink dissolve into a soft wash.

Use the brush tip swiftly and freely, occasionally pressing firmly and then reducing the pressure to produce finer lines. Twist your wrist too.

Block in a light tone using the brush tip, then add a darker tone underneath. Work over the top straight away with the fine point. The line remains crisp on dry paper, but where you touch the areas of blocked-in colour, the line will 'bleed' a little.

Using the brush tips of two different colours, see how a third colour is created when the second colour is applied over the first.

Mixed media

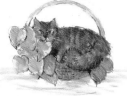

Next, I'd like you to try mixing your media. As you can see from my illustrations, you can create some wonderful effects, which will lead to exciting and vibrant sketches. I've tried a few options. Don't be afraid to experiment, in order to discover even more.

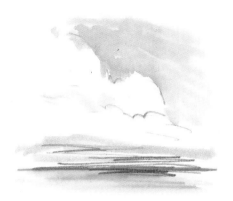

Make some lines with a pencil and use the brush tip of a watersoluble art pen over the top. My lines suggested sky and cloud, so I chose blue. I then melted the brush marks with clean water.

Use the side of a piece of charcoal first, flat against the paper. Blend the marks with a finger. Then use black and sanguine conté over the top, and finally pick out light shapes with a tiny piece of putty eraser.

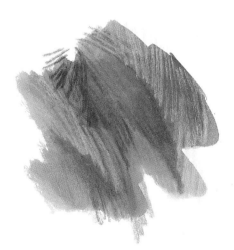

Create a block of colour with the brush tip of an art brush pen. Then 'dissolve' the marks with water, using a paintbrush. Use pastel pencils over the top, feathering the lines so that the underneath colour shows through.

Make some lines with the fine tip of an art pen. Then use coloured pencils gently over the top, beginning with your lightest colours. Where you overlay colours, subtle new ones will be created.

MAKING OBJECTS LOOK 3D

Most objects are three dimensional, so we have to find a language to translate those three dimensions into a flat, two-dimensional drawing. If we simply draw the outline of the object, that isn't enough to give the impression of three dimensions – the 'form' of the object. Shadows will help to describe the form – and sometimes the object will have lines 'within' it that will help too. Let's see what I mean.

Form

Try copying this example. Then find similar objects at home and draw them using the same principles to describe the three-dimensional form. I used a 2B pencil for this sketch.

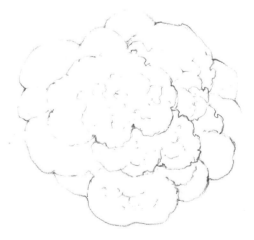

1 *Here is a simple, amorphous shape. It could be anything – it could certainly be flat, like a coaster. Or it could be a hole!*

2 *Now I have added 'internal' lines. The object now has form – it is full, round, and has bumps. Notice how the overlapping lines explain the cauliflower's form. Also, see how the lighter lines on the left give the impression of light falling on the object.*

Ball

How you draw your 'internal lines' makes a difference too. See how straight lines give the impression of a flat surface.

Here, the curved lines show us that we are looking at a round object.

Teddy bear

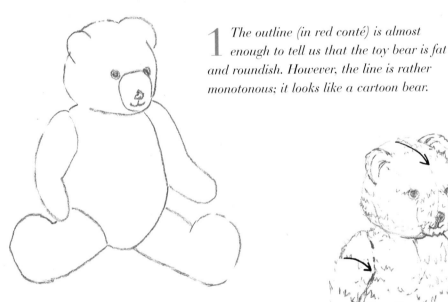

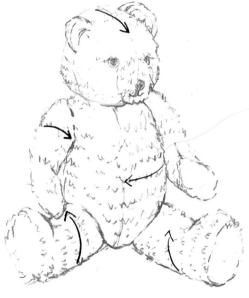

1 *The outline (in red conté) is almost enough to tell us that the toy bear is fat and roundish. However, the line is rather monotonous; it looks like a cartoon bear.*

2 *In this drawing, the small lines used to describe the bear's fur curve around his shape. I have also left the central line that I used to 'search out' the shape of his head; this line helped me to plot his features in the right place.*

Shadows

Light, when it falls on an object, will usually cast a shadow, and that shadow will help to describe the shape of the object.

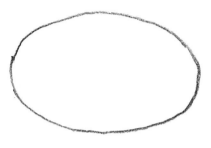

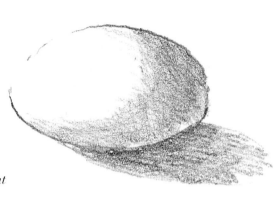

The shape of the egg quickly becomes easy to read when a strong light from the left casts a shadow. 'Tone' – another word for shading – was scribbled on, using the side of a 2B pencil almost flat against the paper.

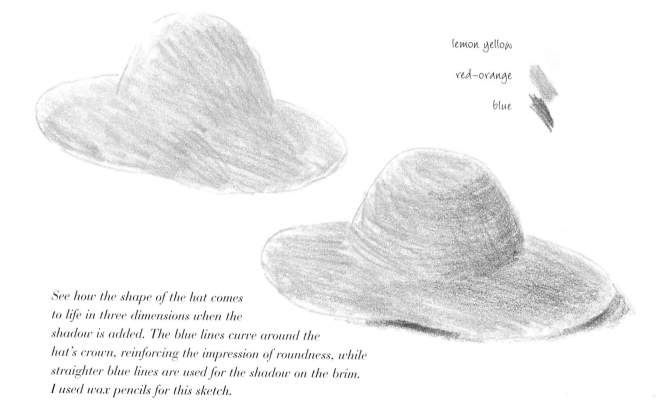

lemon yellow

red-orange

blue

See how the shape of the hat comes to life in three dimensions when the shadow is added. The blue lines curve around the hat's crown, reinforcing the impression of roundness, while straighter blue lines are used for the shadow on the brim. I used wax pencils for this sketch.

Edges

Be careful not to draw a hard line all around your subject, unless you are drawing an 'edge'. Developing an awareness of the difference between an 'edge' and continuous form is important.

In this conté drawing of a vase, I drew the outline of the vase, then added the tone, or shading. The lines used to describe the top and bottom edges of the vase are fine, but the lines describing the sides of the vase seem to bring the sides of the vase forward.

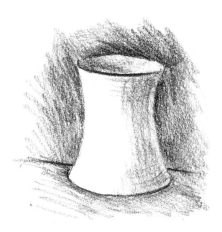

In this drawing, a line is used for the front top edge and for the bottom edge of the vase, but the dark tone behind 'describes' the sides of the vase, improving the illusion of a curving form.

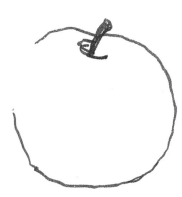

1 *I drew the apple with a watersoluble art pen, leaving a broken line on the left to suggest light falling on the fruit from that side.*

2 *Then I wetted the line, teasing the colour out to form a shadow on the table top, and leaving white paper to suggest the lightest part of the apple. This gives a perfect impression of roundness.*

COMPOSITION

There are times when you want to sketch a whole scene, or produce a sketch with a view to making a painting of that subject at a later date. Composing a picture isn't always easy. Every part of the picture has to be considered – not just the objects in the scene, but the spaces between the objects too. Composition is how you put all these parts together to make a satisfying whole.

Making a viewfinder

The first thing you need will become one of your most useful tools. It is a viewfinder. Every time we turn our heads, even a tiny bit, we see more and more of a view, and it's really hard to know where to begin and what to include. A viewfinder helps to isolate a section of a view, and shows us what the picture might look like.

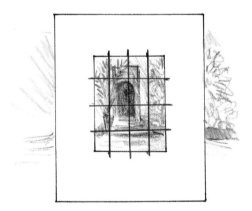

You can cut a viewfinder from a piece of stiff card, minimum size 15 x 10 cm (6 x 4 in). Some artists find it very helpful to tape lengths of black cotton across their viewing window, to create a grid. This makes it easy to check the positions of objects in relation to each other.

Alternatively, use two L-shaped pieces of card, held together with paper clips, or elastic bands. This gives you a simple, adjustable viewfinder.

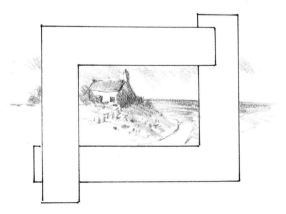

Creating a focal point

A really good way to begin a sketch is to decide immediately upon a centre of interest – technically known as a focal point – and then place this focal point on one of the 'eyes' of the rectangle that you see through your viewfinder. This concept has been used by artists throughout the ages, after it was discovered that the viewer's eye naturally gravitates to these points. It is based on a fairly complex formula, but the principle can be simplified in this way.

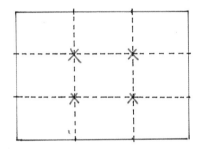

Divide your rectangle into thirds. This will create four points where the lines intersect, and any one of these points is a perfect spot to place your focal point.

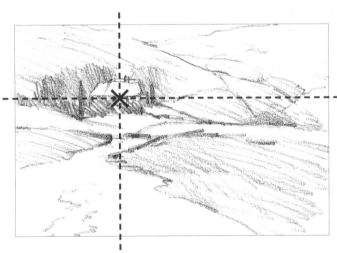

The focal point of this sketch – the house in the hills – sits perfectly on the top left 'eye' of the rectangle.

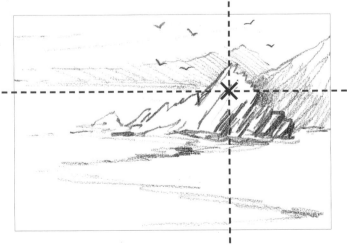

Here, the jagged rocks are the main subject of the picture, placed on the top right 'eye' of the rectangle. The picture feels nicely balanced.

Counterchange

You can stress the importance of your focal point by using strong, dramatic contrasts – setting the lightest part of the picture against the darkest part, or vice versa. This use of light against dark and dark against light is called counterchange; it is very effective indeed, and I recommend you look for opportunities to use it whenever you can. Don't be afraid to exaggerate nature a little if it helps to do so.

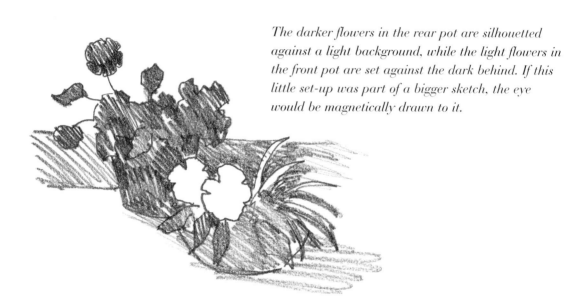

The darker flowers in the rear pot are silhouetted against a light background, while the light flowers in the front pot are set against the dark behind. If this little set-up was part of a bigger sketch, the eye would be magnetically drawn to it.

The dark building is silhouetted against a light sky, and the little bush and pale trees contrast strongly with it. Imagine, for a moment, the trees as dark as the house. It would be very hard visually to separate the trees from the house.

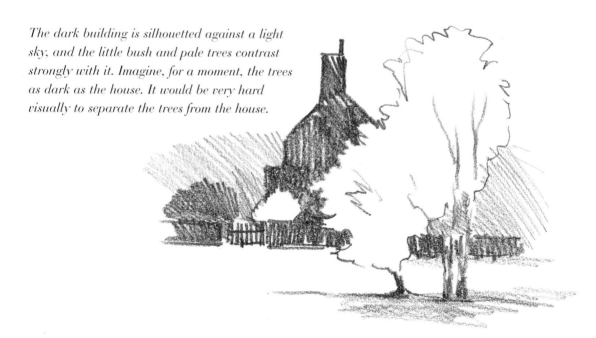

Dos and don'ts

Here are a few pictorial dos and don'ts to consider.

✘

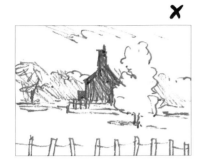

✔

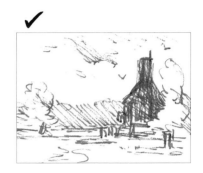

Don't place your focal point in the middle of the picture, and try not to divide your picture in half. Also, don't block off the picture with a fence or wall at the bottom.

✘

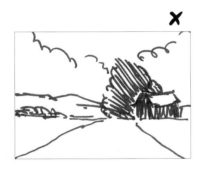

✔

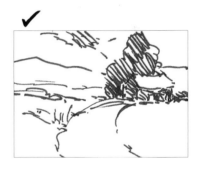

Beware of corners – they can act as arrows leading the eye out of the picture. The picture on the right is far more 'comfortable' and we are led directly to the focal point.

✘

✔

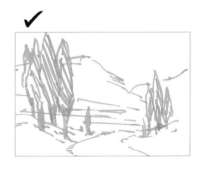

Although it's good to have similar shapes in a picture, which echo each other, vary their proportions, and don't create 'bookends' at either side of a picture, with shapes of equal size.

✘

✔

Don't butt shapes together, even if that's how they appear in nature. Making objects overlap describes the space between them.

FRUIT AND VEGETABLES

In this chapter, we will look at some of the important elements of drawing – how to begin, combining objects, creating texture, and assessing proportions. Fruits and vegetables are great starting points for learning to sketch. Because fruits and vegetables are natural forms, they all differ slightly, so we have to look really hard to find the correct shape.

Pear

Although I used a 4B pencil, you can use any grade of pencil for this exercise. Work lightly to begin with.

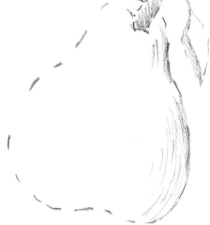

1 Pears are great fun to draw. First draw the shape with a 4B pencil. A broken line may help to give you confidence.

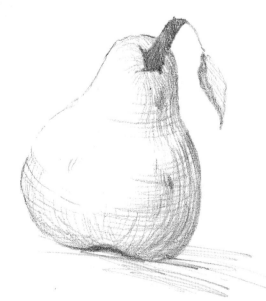

2 Now you can 'firm up' the line, perhaps leaving it light and open where the light hits the pear. This emphasises the sense of three dimensions. For the shadowy side, use lines which curve around the form, 'feeling' the shape of the pear with your pencil. Where the shape changes direction, allow your lines to change direction. Build up the shading gradually, pressing hardest for the darkest parts.

Nectarine and banana

Now let's put two fruits together, one overlapping the other, to practise putting objects together convincingly. This time, I used a piece of charcoal.

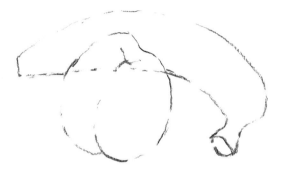

1 Using the point of the charcoal, begin with the outlines of the fruits. Where one fruit is behind another, follow the line through, to ensure that the drawing makes sense.

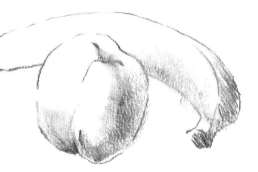

2 Using the side of the charcoal, put in the shadowed side of the fruits, and gently blend the charcoal with a finger.

3 Add the shadow on the table top, looking hard to see which is darker, the shadow or the fruit. Build up the form of the fruits. Add any tiny details, such as markings on the banana. If you want to 'lift' any unwanted charcoal, to refine the drawing, use a tiny piece of putty eraser. When you finish, spray with fixative. (Notice the tiny area of reflected light on the shadowy underside of the nectarine. When you place an object on a light surface, reflected light often bounces up onto it.)

Strawberries

It isn't necessary to draw with a graphite pencil then colour your sketch in. Working directly with a coloured pencil immediately captures the colour of the fruit.

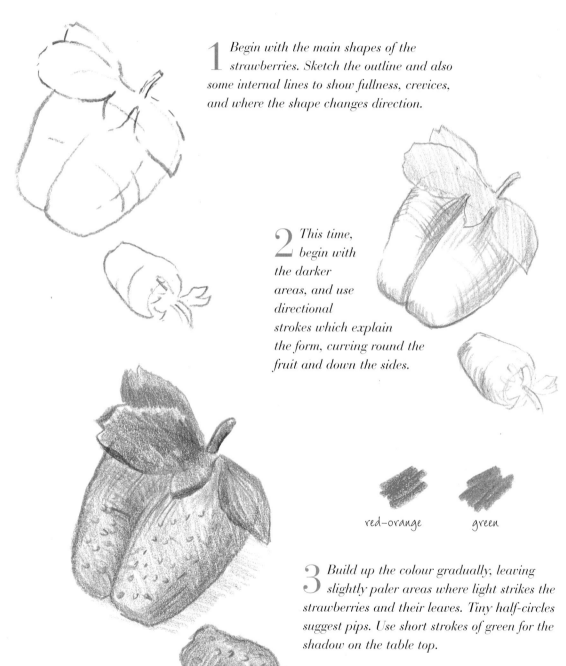

1 *Begin with the main shapes of the strawberries. Sketch the outline and also some internal lines to show fullness, crevices, and where the shape changes direction.*

2 *This time, begin with the darker areas, and use directional strokes which explain the form, curving round the fruit and down the sides.*

red-orange green

3 *Build up the colour gradually, leaving slightly paler areas where light strikes the strawberries and their leaves. Tiny half-circles suggest pips. Use short strokes of green for the shadow on the table top.*

Fruit sections

Cutting fruit into segments will give you unfamiliar shapes to sketch. This is a very good way of training eye/hand co-ordination. Try really hard to get the proportions right, just by eye. I used conté for these sketches.

1 *Cut an apple into segments. Set two pieces together, and before beginning to draw them, blur your vision by squinting so that you can only just see the pieces. Looking at them in this way will eliminate all detail, and will fuse the two shapes into one, larger shape. Try drawing the outline of the two together, looking hard at the shape created where they overlap.*

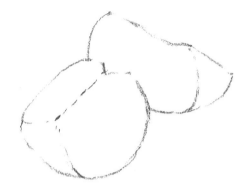

2 *When you are satisfied with your large shape, look to see where the 'planes' of the segments change. The top, central line of my front segment was not in the centre, as you might have expected.*

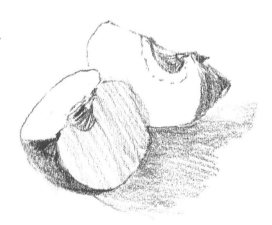

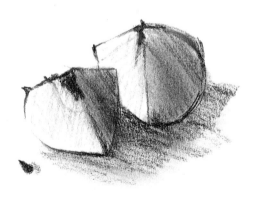

3 *Finish off the sketch by putting in the tones of the shadowed sides of the fruit, and the shadow on the table. My table shadow was darker than the fruit shadow.*

These tiny segments – a quarter cut in half again – didn't look at all like apple; I just had to draw what I could see.

Onion

The golden rule – and I use the term loosely because actually, there are no 'rules' about drawing – is form before texture. In other words, we have to make the object look three dimensional before we allow ourselves to tackle the fun part – the surface texture.

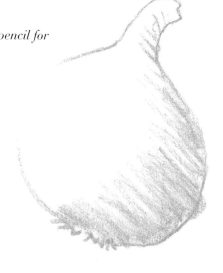

1 *I have chosen an orange pastel pencil for this lovely golden-orange onion. Firstly, I drew the shape of the onion, and scribbled some tone onto the shadowed side.*

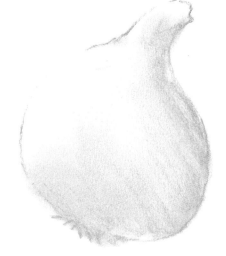

2 *Using a finger, I gently blended the pastel strokes into the paper, to create the full, rounded form of the onion. If your blending doesn't look quite right, you can remove some colour with a putty eraser.*

3 *Finally, I added the texture of the onion skin. Pressing hard, I was able to suggest the edges of broken skin, and lightly drawn lines, following the form of the onion, imply the 'lines' on the onion.*

Mushroom

Judging proportions by eye isn't always easy. You can check proportions by using artists' measuring. Hold out a long pencil or stick, with your arm very straight and the elbow locked. The pencil must not point at the object, but either at the ceiling when you are checking the height or the wall to your left or right for the width. Close one eye, line the top of the pencil up with the top of the object, and place your thumb on the pencil in line with the bottom of the object. This will become your measuring unit and you can use it to check all other parts in relation to this unit as you draw.

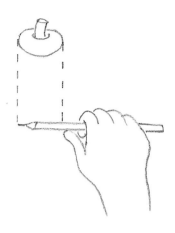

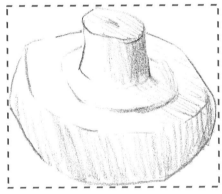

1 *This mushroom, sketched in coloured pencil, is only very slightly wider than it is high. You can check this with a ruler.*

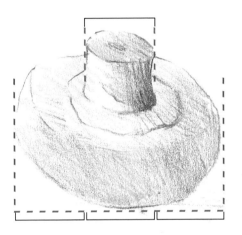

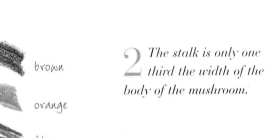

brown

orange

blue

2 *The stalk is only one third the width of the body of the mushroom.*

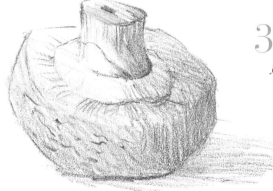

3 *After establishing the main shape, and the changes of plane which show the form, the colour was built up gradually, working one colour gently over another. Only three colours were used, but overlaying creates interesting nuances of colour.*

EXERCISE Sketch some fruit

You can copy this sketch, but then you will find it rewarding to set up your own still life, using similar fruits. If strawberries are out of season, use any other small fruits, to give a change of scale from the larger pieces.

1 Set up the fruits with light coming from one side. Using a 4B pencil, lightly sketch the outlines of the fruits. It helps to straighten curved lines a little, as I have done. It can also help to create an imaginary 'grid' in your mind's eye, or even hold out your pencil, to see where objects line up with each other.

2 Now half close your eyes and squint at the group. Begin to develop the tone – shading – on the fruit, starting with the darker sides. This should immediately give the fruit three-dimensional form. Try to make your lines 'wrap around' the curved fruits.

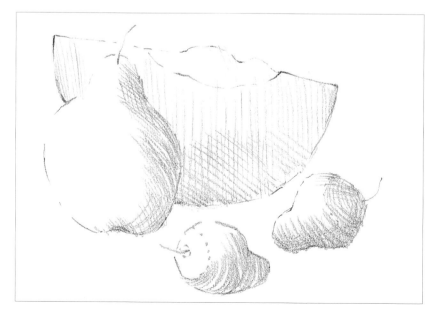

lightest
tone

medium
tone

darker
tone

darkest
tone

3 *Continue to develop the forms of the fruits by adding more shading, looking carefully to define the darkest parts – for example, the shadows under the fruits. Add the shadows on the table top. Begin to define some detail, such as the tiny leaves on the tops of the strawberries.*

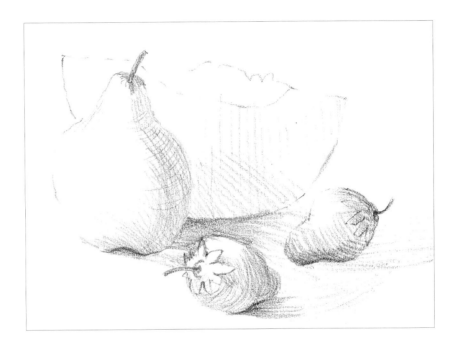

4 *Gradually add more shading. You can take this step as far as you like, even using the side of the pencil lead to close up the lines and darken areas. Finish off with details – the pips on the melon, and the texture on the strawberries.*

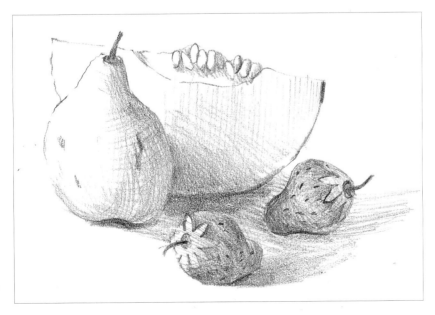

You can paint 37

NATURAL FORMS

As you sketch natural forms, you will become aware that nature is a wonderful artist. Many natural objects have beautiful shapes, colours and patterns, and sketching these will train you to investigate how things are made as well as how they look. Start with fairly simple items, and build your confidence to tackle more complex forms.

Pebbles

These two pebbles were smooth and round, and one seemed to have a built-in, circular pattern, which echoed its shape. If you look hard to find the natural rhythm of construction and see how the pattern follows the form, this will help a great deal. The danger is drawing the patterns as if they were on a flat surface, which flattens the object.

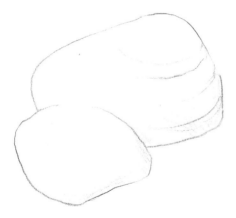

1 *I began with the basic outline, using coloured pencils. Where the pattern was strongest, I indicated this with some circular lines, which followed the form. I also added a little tone, to establish the 3D form.*

lemon yellow

purple

dark blue

green

blue

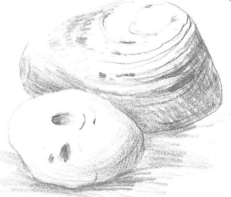

2 *I gradually added more colour; one pebble was more yellow than the other, which was grey-green. As I built up the colour, I tried to suggest the pattern while following the form. Finally, I put in the little dents and cracks in the front pebble, and the shadow underneath them.*

Feathers

I used pastel pencils for these drawings, sharpened to a fairly fine point. You can sharpen a pastel pencil by rubbing it gently on fine sandpaper. Press lightly when sketching or the point will break.

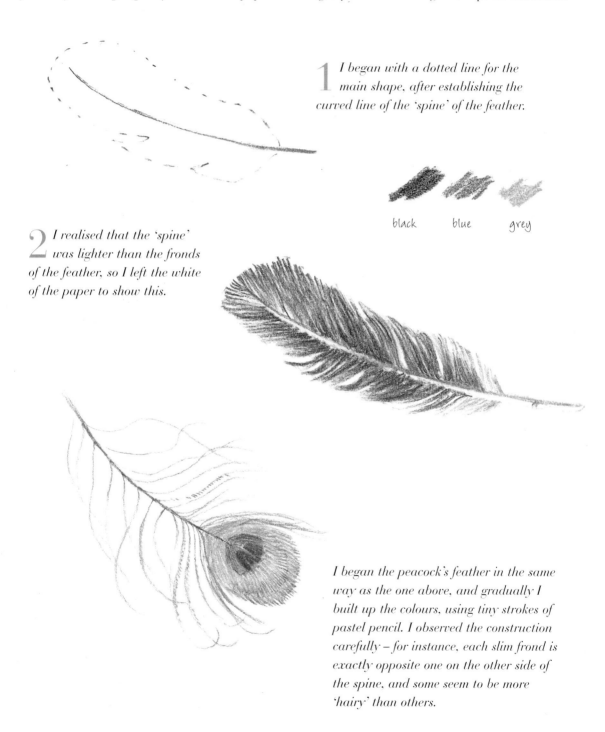

1 I began with a dotted line for the main shape, after establishing the curved line of the 'spine' of the feather.

black blue grey

2 I realised that the 'spine' was lighter than the fronds of the feather, so I left the white of the paper to show this.

I began the peacock's feather in the same way as the one above, and gradually I built up the colours, using tiny strokes of pastel pencil. I observed the construction carefully – for instance, each slim frond is exactly opposite one on the other side of the spine, and some seem to be more 'hairy' than others.

Tree bark

Sketching bark will train you to observe well, but also to simplify too, because it is almost impossible to include every tiny crack and flake. The pattern is quite complex, and if you do not follow the form in places, you could flatten the shape, and lose the sense of three dimensions.

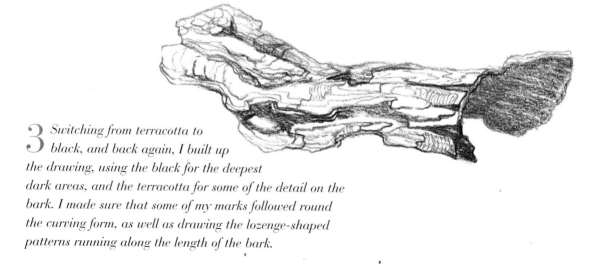

1 I began with a lightly sketched outline, using a terracotta conté pencil. Notice the tiny row of dots across the centre of the form, to remind me that the piece of bark was curved, not flat.

2 Next, I squinted through half-closed eyes, to simplify some of the detail. I indicated the main, deep cracks in the bark, and scribbled in some tone for the dark, shadowy underside of the bark.

3 Switching from terracotta to black, and back again, I built up the drawing, using the black for the deepest dark areas, and the terracotta for some of the detail on the bark. I made sure that some of my marks followed round the curving form, as well as drawing the lozenge-shaped patterns running along the length of the bark.

Seed pod

I used a stick of charcoal for these drawings, a thin piece with a point. To re-point your charcoal, run it gently across a piece of fine sandpaper.

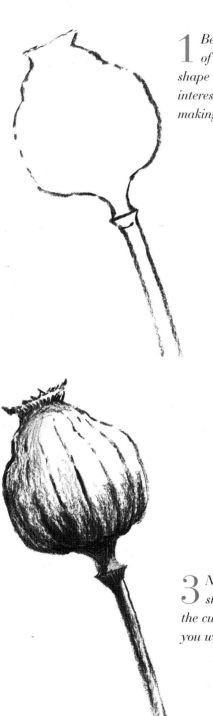

1 *Begin with the basic shape of the object, studying the shape carefully. There may be interesting dents in the surface, making it asymmetrical.*

2 *Now try to find lines which explain the form. In this case, the seed pod had shallow grooves running from top to bottom, and they curve around the form nicely. Spray fixative on this drawing.*

3 *Now work lightly over the top with short strokes, defining the way the light describes the curving shape, and hits the stalk. Squint as you work; it will simplify the tones.*

DEMONSTRATION SHELLS

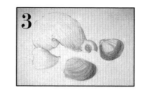
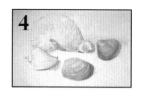

1 *For this picture, I used coloured wax pencils. Begin with the outlines of the shells, checking the positions of the shells in relation to each other. If you look carefully, you might just see the faint lines I used for this purpose.*

2 *Add tone to show the shadow side of the shells – the light was coming from above and to the left. For the smaller shell on the left, curve the lines to follow the form. For the big shell, simple cross-hatching will suffice, as the pattern is strong and this will come later.*

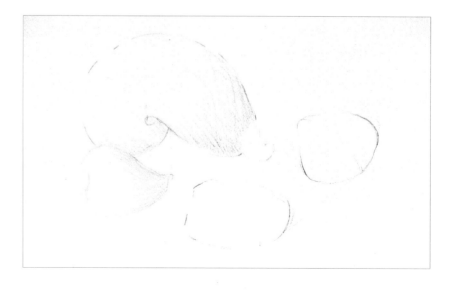

The palette

Wax pencils

blue-grey red-violet

yellow-orange warm brown

3 *Work on the three remaining shells, using blue-grey on the smaller shell at the back of the group, and a mixture of blue-grey and red-violet on the purple shells. Make sure your marks curve around the form.*

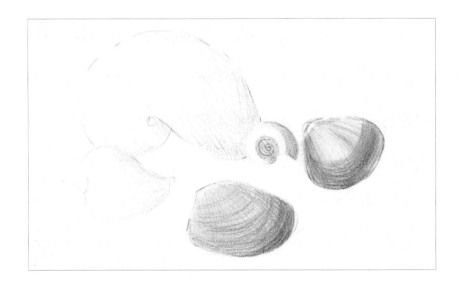

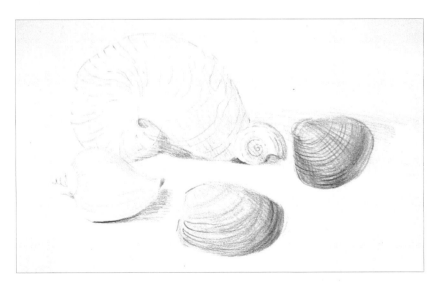

4 *Use simple outlines to describe the patterns on the shells, and begin to suggest some of the shadows underneath them.*

You can paint 43

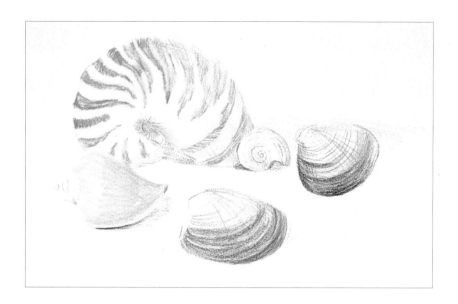

5 *Complete the pattern on the largest shell. The pattern breaks up into lines, and the tone varies from solid and dark, to lighter and finer. Add some yellow-orange to the shell on the left, which is a warmer colour, and emphasise the pattern on the purple shells.*

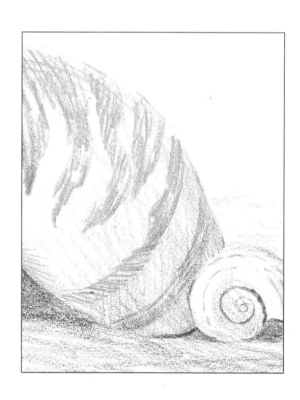

Detail: *The detail shows clearly how the pattern 'sits' on the top surface of the shells, following the curving form. Even the small shell has a shadow to explain the 'dip' in the shell.*

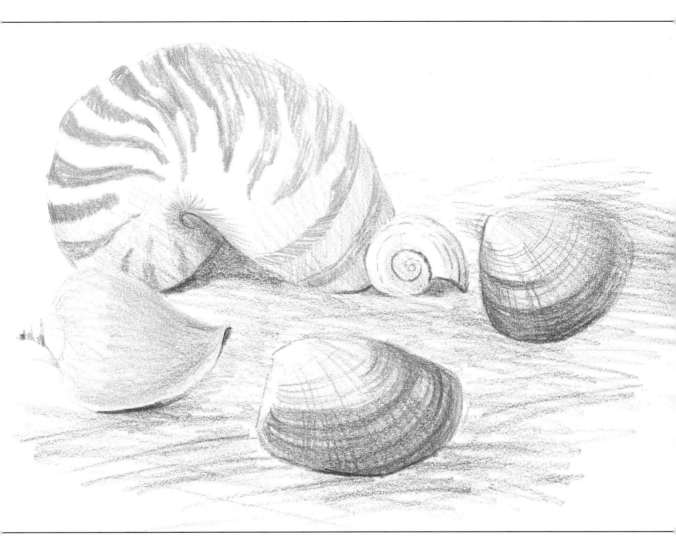

6 *Finished picture:* Tinted watercolour
paper, 17 x 26 cm (6 ½ x 10 in).
*Now it is time to complete the sketch by firming
up details. Where the shells meet the ground,
there is a dark line; the pattern on the purple
shells can be exaggerated a little, and further*
*lines curve over the shell to suggest the form.
A little blue-grey stroked across the large shell
will help the bottom part to recede. Finally,
use vigorous lines of blue-grey, red-violet,
and yellow-orange for the ground on which
the shells sit.*

PLANTS AND FLOWERS

Flowers have naturally undulating, rhythmic lines, and I'd like you to try to get a little 'flow' in your sketches when you tackle their lovely forms. This doesn't mean that you should sacrifice close observation. You are training your eye and hand, and gradually, fluency will come, and with it, the ability to work more freely. Without the underpinning of good observation, 'free' sketches can become sloppy sketches.

Cosmos: open face

I suggest you begin with simple, open-faced blooms such as this Cosmos before you try more complex, many-petalled flowers which are trickier to sketch.

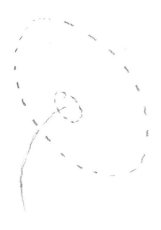 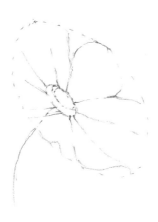 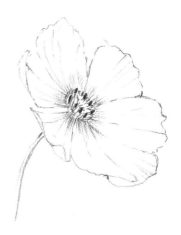

1 Half close your eyes to find the main, overall shape. Find the position of the centre of the flower, and see where the stalk meets the petals – it often helps to follow it through. I have used a 4B pencil for this line drawing.

2 Drawing a flower turning slightly away from you is much more interesting than drawing it 'full-face'. After establishing the structural shape, place the petals carefully, looking hard to see where they overlap, which describes their positions.

3 Finally, study the beautiful varied edges of the petals, and try to represent them faithfully. Fine lines radiating out from the centre show where the petals are curved, and where they are straighter, describing the form without the use of shading.

Cosmos: underside

The undersides of flowers are also fascinating to study, to see how the petals attach to the stem. This is the underside of a Cosmos bloom.

1 *This time, instead of using a simple oval form for the initial construction, I looked hard at the flower through half-closed eyes, and then drew a box with straight edges, which more accurately represented the positions of the petals. Try this yourself with a big, open flower.*

2 *Having established the overall shape, draw the flower with the firm point of a watersoluble art pen. Working with a pen is a bit scary because you cannot rely on an eraser, but it certainly sharpens up your observation. Where the petals are in shadow, you can use additional lines to describe the darker tone.*

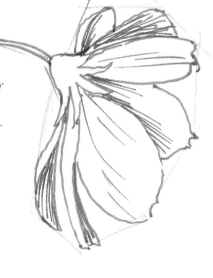

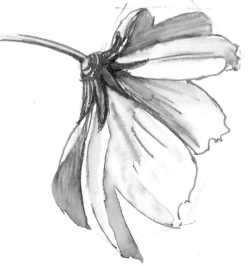

3 *Finally, 'loosen' the ink gently on the darker parts of the petals with a brush and clear water. This will give a lovely, soft, watercolour effect, ideally suited to the subject. When it is dry, you can erase your pencil lines and, if you need to, you can redraw any ink lines which have been washed away.*

Lilac

Now try a slightly more flowing sketch, by choosing a plant with several leaves, and more than one stem. The curving plant I have chosen suggests growth, life and movement. While this sketch is quite 'free' and lively, it is still carefully observed. I have used just four coloured pencils – green and orange for the stem and leaves, and two purples for the flowers.

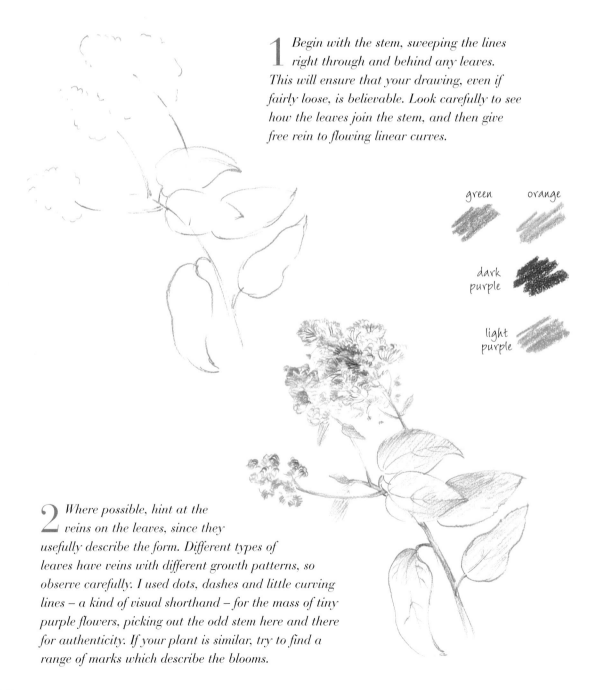

1 *Begin with the stem, sweeping the lines right through and behind any leaves. This will ensure that your drawing, even if fairly loose, is believable. Look carefully to see how the leaves join the stem, and then give free rein to flowing linear curves.*

green orange

dark purple

light purple

2 *Where possible, hint at the veins on the leaves, since they usefully describe the form. Different types of leaves have veins with different growth patterns, so observe carefully. I used dots, dashes and little curving lines – a kind of visual shorthand – for the mass of tiny purple flowers, picking out the odd stem here and there for authenticity. If your plant is similar, try to find a range of marks which describe the blooms.*

Drawing containers

Sketching plants and flowers in pots or vases means that you have to include a very symmetrical, man-made object. If you draw a pear or a leaf incorrectly, the mistake may not show, and may even add character – but if you draw a vase wrongly, it will be obvious. Here are a few hints, to help you to draw symmetrical objects correctly.

Usually, pots and vases are round, but instead of a circle, you will see an ellipse at the lip, and at the base. Always measure the proportions carefully – a common mistake is to make the opening either too wide, or too deep.

At eye level, the curves straighten out.

Look carefully at the curve formed by the lip and base. We usually look down on pots and vases, so the curves will be below our eye level. The further down we look, the deeper the curve. See how the curve at the base of my pot is deeper than the curve of the lip.

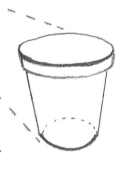

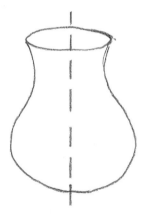

Looking up, curves will arc upwards. If you struggle with this, hold a glass in your hand and see what happens to the lip as you move it up and down.

If your object has a complicated shape, it can be difficult to get both sides right. Drawing a centre line will help, and if all else fails, you can trace over one half, and turn the tracing over to check the other half.

DEMONSTRATION POT OF FLOWERS

AT A GLANCE...

 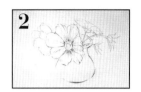 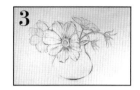 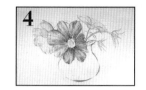

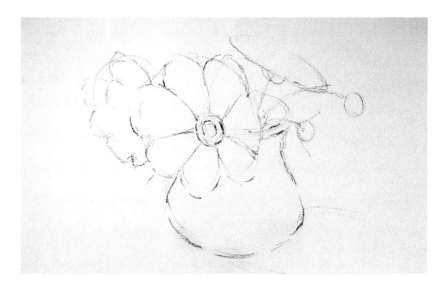

1 On soft grey pastel paper, using charcoal, begin by sketching the main large shapes of the flowerheads – in this case, circles and ovals, and check dimensions carefully. Look to see where centres come – the centre of the big bloom was off-set slightly to the right.

2 I used my charcoal to define the shapes of the petals more carefully, adding lines of charcoal at the base of the petals, where the colour was very dark. Charcoal can easily be rubbed off with a putty eraser, so don't hesitate to correct any mistakes.

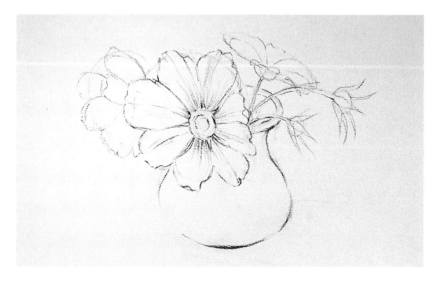

50 You can paint

The palette

Pastel pencils

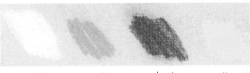

white pale green dark green yellow

pale blue pale pink dark pink charcoal

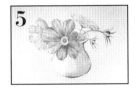 **5**

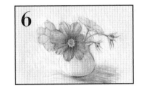 **6**

3 *Before using colour, spray the drawing with fixative. For the colour, I worked from light to dark. Use pale pink for the lightest parts of the blooms, and pale green for the lightest parts of the stems and also for the leaves on the buds.*

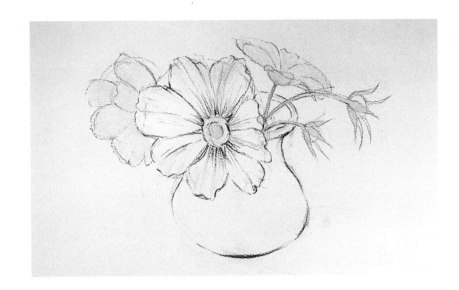

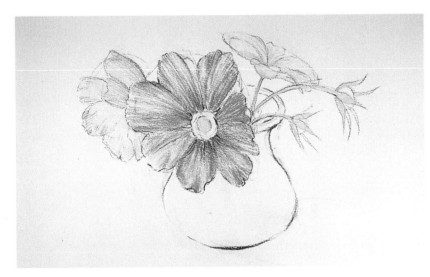

4 *Use the darker pink for the main flower. Make long and sweeping marks, following the form from the centre to the outer edge. Petals often have little ridges that describe their form beautifully. Notice how the pastel pencil marks blend nicely with the charcoal.*

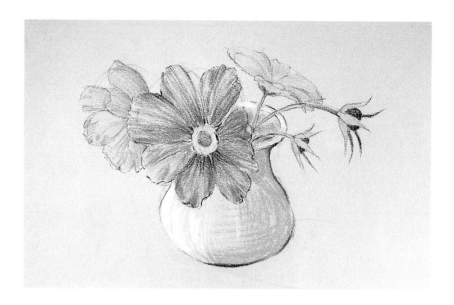

5 Work on the flower centres, and then the pot. The pot was illuminated from the left, so use white for the left hand side, and pale blue for the side in shadow. Look carefully at my marks – can you see that I have curved them around the pot? This is done from the top to the bottom, and also around the pot from right to left. As a result, the viewer can clearly understand the fullness of the pot. When you have completed the shadow on the pot, use the same pale blue on the light coloured blooms at the back, to hint at shadows on the petals.

Detail: It is possible to see the charcoal marks, despite the fact that these flowers don't have dark edges. For a sketch, this is fine, but you can use colour from start to finish if you prefer.

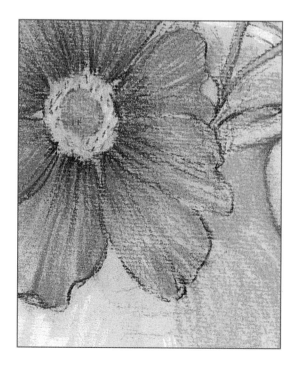

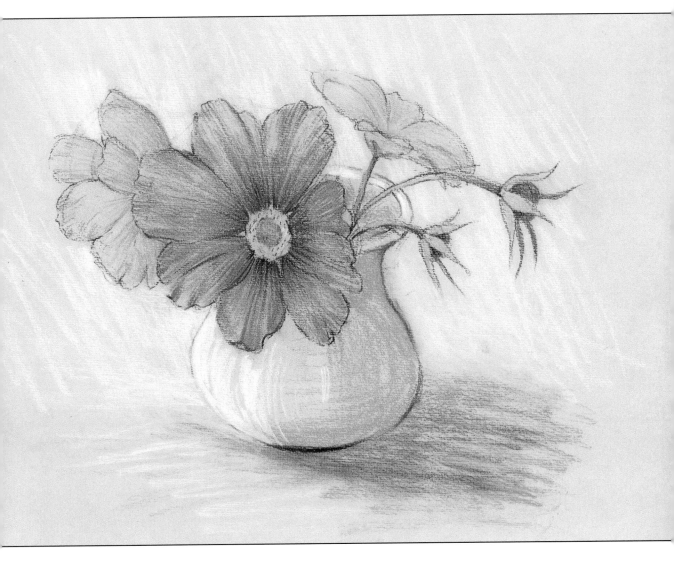

6 *Finished picture: Pastel paper, 21 x 28 cm (8 x 11 in). Complete the sketch by adding a shadow on the ground – begin with a little charcoal, and add pale blue over the top. Deepen the darkest parts of the petals on the big flower, by pressing hard with the dark pink.*

Scribble some white on the ground to the left of the pot, and then behind the pot and flowers to suggest a background. Sharpen up here and there with tiny touches of charcoal – under the pot, between petals, in the centres and on the little buds. Spray the sketch with fixative.

TREES

Deciduous trees have a basic structure of trunk, branches and twigs, which can easily be seen in winter. This is a very good time to study trees, and to sketch lots of them in order to learn how they grow. When you do this, look hard and don't generalise. Explore how branches join trunks, and twigs join branches.

Winter tree

Standing well back from a large tree, you can see the whole shape. Each different type of tree has a characteristic shape, so observe carefully – they vary dramatically. Trees are as individual as people, so it would be wrong to generalise their shapes.

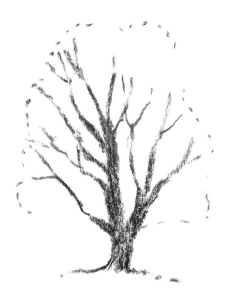

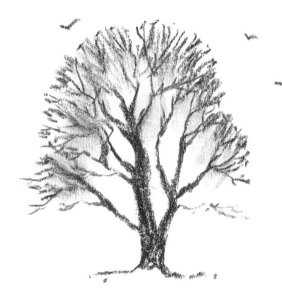

1 *With black conté or charcoal pencil, sketch the trunk and main branches. Half close your eyes to simplify the tree's shape, and use dots to indicate the outer limits of this shape.*

2 *Tiny strokes around the outer edge will suggest the mass of twigs, and gently softening with a finger gives the impression of fullness.*

Tree trunk

It is fun to study trees. As well as having different shapes, their textures vary too. I used a 4B pencil for these drawings. Do try sketches like these in conté, and pastel pencils too.

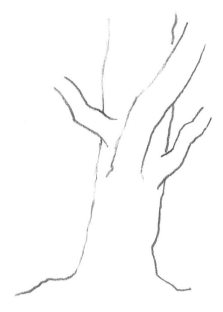

Begin with a tree trunk. Notice how the tree flares out at the base, how the branches join the trunk, and that most branches stay the same width until they fork – they do not taper.

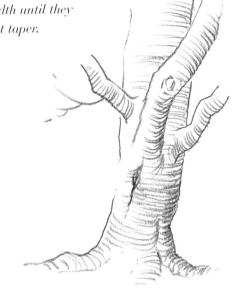

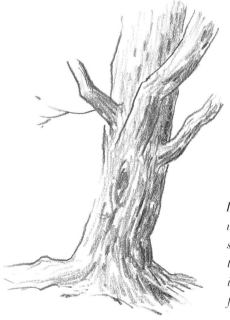

Now try two different ways of expressing the form, and the texture of the bark. The first example shows curving lines running around the form. As we look up the tree, the curves arc upwards and looking down the tree, the curves swing down. The lines curve under the branches, and dip into hollows.

In the second example, bark is suggested with a series of parallel strokes, some light, some heavy. Heavier marks on the right of the trunk, and under the branches, give the impression of round forms revealed by light from the left and above.

Branches

A vital thing to notice about tree branches and twigs is that they don't actually taper. This is a common misconception. Look closely, and you will see that branches grow for a while, then throw off smaller branches, which in turn throw off even narrower twigs.

1 Begin by drawing branches carefully, observing both the width of the branch, and the changes of contour and direction. Look at the shapes between the branches, this may help too. I sketched this in black conté.

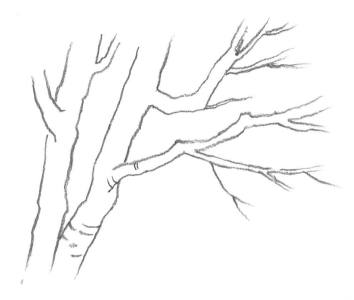

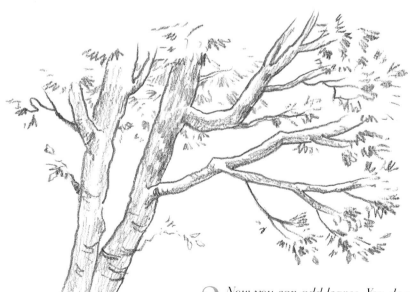

2 Now you can add leaves. You do not need to draw every leaf carefully – short, stabbing marks can be enough to suggest foliage. You could add the occasional proper leaf shape, since leaves vary from tree to tree.

Summer tree

Trees in full foliage can be daunting to tackle — all those leaves — so we have to learn to simplify their shapes, to seek out the main masses or clumps of foliage, and find a suitable visual shorthand to use.

1 Using a brown pastel pencil, begin with the main shape of the tree, making sure you 'plant' the tree in the ground.

2 Simplify the tree into its main clumps of foliage. Look at the direction of the light – light from the sky and sun will provide shadow areas which you can define with simple parallel lines of shading. Add a shadow on the ground and soften the colour gently with a finger.

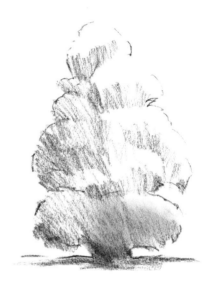

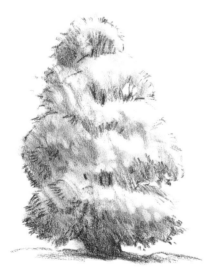

3 Use a putty eraser to lift out some of the colour from the lighter areas, to give variations of tone in the foliage. Create some holes in the foliage, in order to see the sky behind. With your pencil, deepen the tone of the trunk, add branches in the sky holes and within the foliage, and use tiny dots and strokes to suggest leaves, and a filigree edge to the tree.

EXERCISE Sketch a tree

A simple image of a tree, with a rickety fence, makes an ideal sketching subject. Try copying mine, then find a similar one to draw from life for yourself. The tree is the important part of this sketch: the fence is a fun extra.

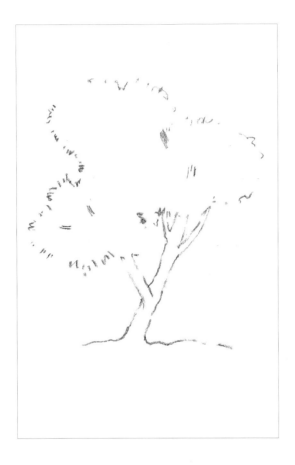

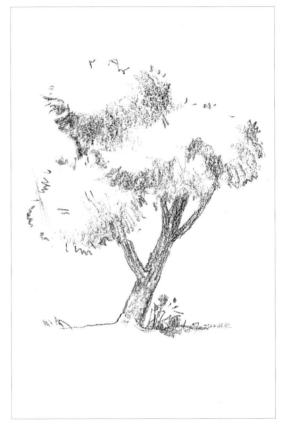

1 *Using black conté, firstly establish the main shape of the tree, and any branches which can be seen through gaps in the foliage. Look carefully to discover the direction of the light, and see if it reveals the main, large clumps of foliage.*

2 *Use the side of the conté crayon to block in the darker sides of the foliage clumps, and bring the dark tone down onto the tree trunk. The tree will cast its own shadow onto the trunk, so it will be darker under the foliage than at its base. Suggest some of the grasses on the ground with little strokes and dots.*

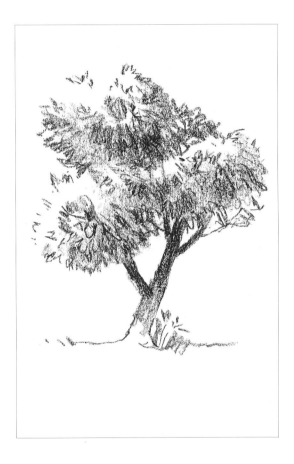

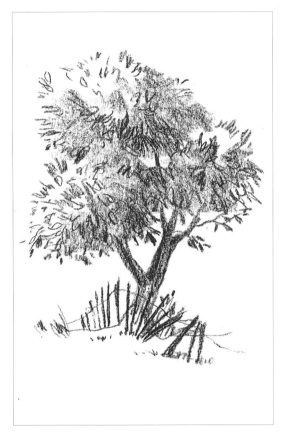

3 *Now you need to find a kind of shorthand for the leaves on the tree. Look closely at my drawing, and you will see that I have mostly used short strokes, or little v-shapes, and the occasional lozenge-shape. If you feel a bit tentative, try out some marks on a spare sheet of paper before working on your tree.*

4 *Add in some leaf shapes, particularly around the edges of the tree. Look at mine on the right, and in the space in the fork of the tree. Actual leaf shapes help to give the tree character, and the drawing credibility. Finally, draw in the old fence. This is easy and fun – just a few straight lines at different angles, joined up with a fine line.*

SKIES

When working outdoors, the wind blows things around, shadows move and light changes. You have to learn to work quickly. If you like the idea of a bit of practice before embarking on this adventure, try sketching skies from a window. This will teach you to work quickly, because clouds change shape in seconds. There are many different types of clouds, and it helps to know their types, but for the beginner, it's best to simply look hard and sketch what you see. Try using different media, until you find the one which suits you, and the subject, best.

Clouds in pencil

Use your softest pencil – 4B or even 6B – which gives marks that are easier to erase than hard pencil lines.

1 *Quickly indicate the outline of the largest cloud you can see, pressing lightly and leaving lots of gaps.*

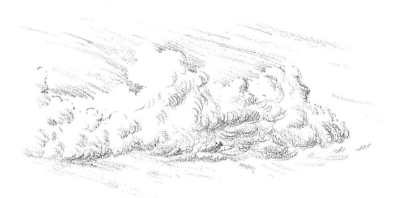

2 *Assess where the light is coming from. Then, using the side of the lead, add some simplified shading to give the cloud 3D form. Try not to make your shapes too monotonously 'lumpy' or hard-edged – clouds are soft and wispy. Lift too-hard edges, or overworked areas, with a putty eraser.*

Stormy clouds in charcoal

Charcoal is a superb medium for sketching storm clouds and skies. You can 'move it around' with your fingers, build up layers, and using it on its side, the soft-edged qualities you create are very much in tune with the nature of clouds.

1 You don't, strictly speaking, need to begin with an outline, but if you feel you need one, lightly begin with the sharp point of the charcoal. You can soften the marks with your finger if you wish.

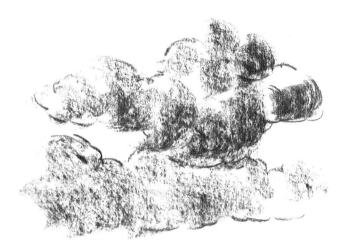

2 Switch to using the side of the charcoal, using a fairly short piece, about 5 cm (2 in) long. Twist your wrist as you work, to suggest the curved undersides of the clouds in places, as I have done with the nearest cloud.

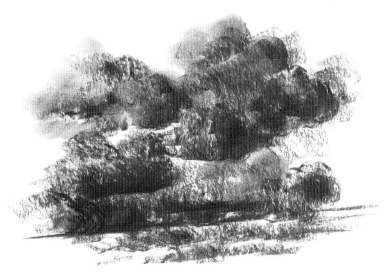

3 Pressing harder with the charcoal still on its side, build up the layers of charcoal to suggest ominous black clouds. Soften some top edges with your finger, and sweep the charcoal across the paper to create the horizontal bases of the clouds. Finally suggest some smaller clouds towards the horizon.

Summer clouds in watersoluble pencil

I used just three watersoluble pencils for this sky and fluffy cloud: blue-violet, cobalt blue, and turquoise-green, plus some clean water. I worked on thick watercolour paper, because it does not buckle when water is added.

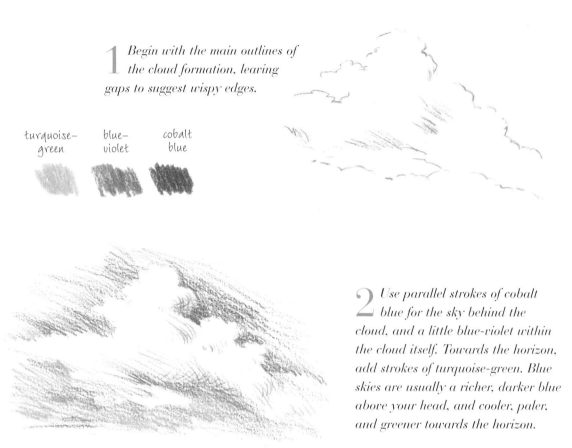

1 Begin with the main outlines of the cloud formation, leaving gaps to suggest wispy edges.

turquoise-
green

blue-
violet

cobalt
blue

2 Use parallel strokes of cobalt blue for the sky behind the cloud, and a little blue-violet within the cloud itself. Towards the horizon, add strokes of turquoise-green. Blue skies are usually a richer, darker blue above your head, and cooler, paler, and greener towards the horizon.

3 As a sketch, it was complete enough at the last stage, but if you wish to exploit the watersoluble pencils to the full, loosen the colour with a brush and clean water. If you use plenty of water, the colour will float around and most of the lines will disappear. Any remaining lines give the impression of a blue sky you could fly through!

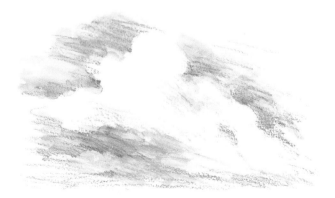

Sky in watersoluble art pen and pastel pencil

Skies and clouds aren't always blue and white. Different times of day, and different types of weather, can create wonderful colour effects. For this warmer dusk sky, I used two very different types of materials. Don't be afraid to mix your materials – anything goes, to achieve the effect you desire.

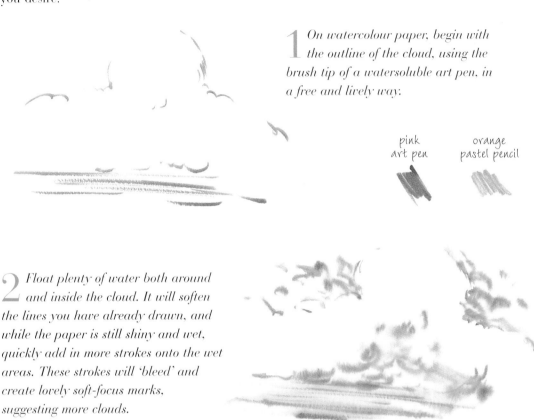

1 On watercolour paper, begin with the outline of the cloud, using the brush tip of a watersoluble art pen, in a free and lively way.

pink
art pen

orange
pastel pencil

2 Float plenty of water both around and inside the cloud. It will soften the lines you have already drawn, and while the paper is still shiny and wet, quickly add in more strokes onto the wet areas. These strokes will 'bleed' and create lovely soft-focus marks, suggesting more clouds.

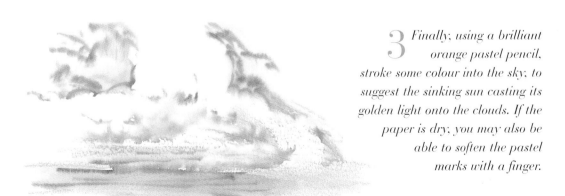

3 Finally, using a brilliant orange pastel pencil, stroke some colour into the sky, to suggest the sinking sun casting its golden light onto the clouds. If the paper is dry, you may also be able to soften the pastel marks with a finger.

Sketch towering clouds

I chose a simple combination of black and white on a warm-coloured ground for this dramatic and effective sketch. It proves that you don't always have to use blue for sky! Try different coloured backgrounds for varying effects.

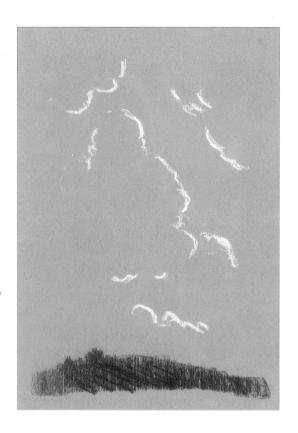

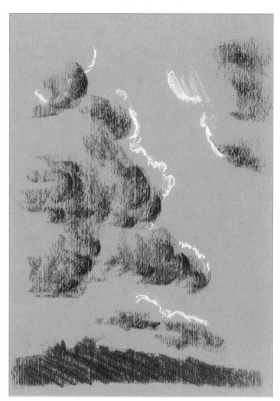

1 *On coloured paper – or white paper stained with a used teabag – use the side of a piece of charcoal to suggest a hillside with a few trees. Then position the clouds with the point of a white conté stick, or white pastel pencil.*

2 *Using the side of the charcoal again, block in the darker parts of the clouds, to suggest fullness. Use curving strokes to emphasise the form of the clouds.*

The palette

Conté crayon
Charcoal

white
conté crayon

charcoal

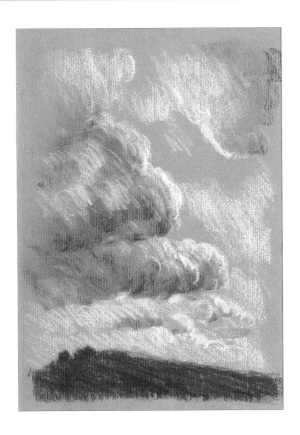

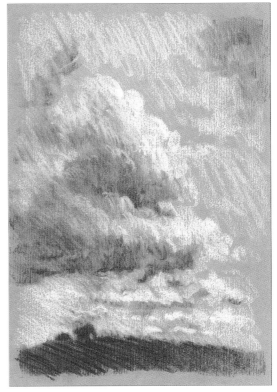

3 *Smooth some of the charcoal marks into the paper with a finger. Then begin to sketch in the lighter parts of the clouds with white, using some curving linear strokes, following the form of the clouds, and simple side strokes for wispy clouds against the sky.*

4 *Build up the forms of the clouds, using charcoal for the bottoms of the clouds, and marks in white for cloud tops and details. Where the white mixes with the charcoal, it forms a useful soft grey, which adds to the feeling of fullness. Press hard with your white for sharply lit edges. Spray fix the sketch.*

WATER

Since water is, basically, transparent, we are actually sketching surface reflections, rather than water itself. These reflections are constantly in motion, even in apparently still water, so we have to try our best to capture this movement. Once again, half closing your eyes will help you to simplify what you see, and this is most important; you don't need to capture every ripple or eddy.

Still water

Begin these exercises with charcoal, choosing a fat piece which can be used on its side easily.

1 Using the side of a piece of charcoal, make a few vertical overlapping strokes. As in the bottom half of my illustration, blend these strokes with your finger.

2 Now for the magic part. Break off a small piece of putty eraser, and mould it to a point with your fingers. Stroke it horizontally across the charcoal, to give the impression of gentle surface movement. As you look across a stretch of water, these marks will gradually close up, giving the suggestion of space.

Reflections in calm water

Objects reflected in calm water can appear to be mirror images, but there are some slight differences which you need to observe carefully. Dark objects are always slightly lighter; light objects (including the sky) are very slightly darker. Tiny ripples will break up the reflections, leaving gaps.

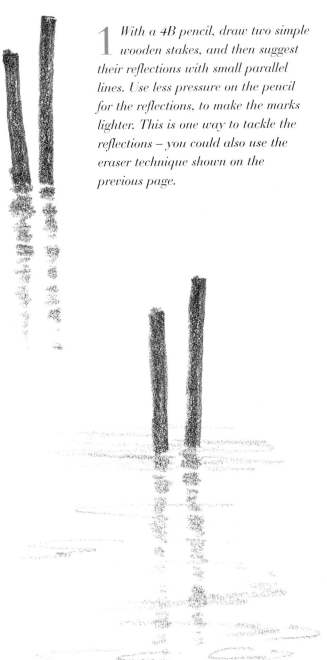

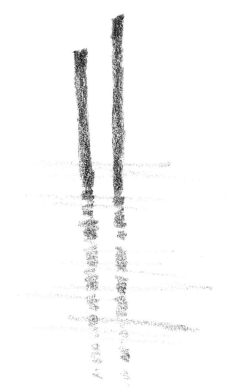

1 With a 4B pencil, draw two simple wooden stakes, and then suggest their reflections with small parallel lines. Use less pressure on the pencil for the reflections, to make the marks lighter. This is one way to tackle the reflections – you could also use the eraser technique shown on the previous page.

2 Lightly draw some horizontal lines across the reflections, to hint at the surface of the water.

3 Add several more ripples, particularly closest to you, where any ripples will be larger and more defined.

Moving water

Wind will disturb the surface of pond and lake water, creating waves, and water will create patterns as it runs along. Rocks in the path of moving water will force the water to swirl around them. Before sketching moving water, spend time simply watching and analysing what you see.

pale turquoise

bright blue dark green

1 *Using a pale turquoise and a bright blue pencil, draw a series of shallow curved lines, allowing some of them to meet in little inverted v-shapes for the wave tops.*

2 *Now sketch in the right-hand sides of the waves, using firm strokes of blue and dark green. Leave the paler colour to 'read' as light on the surface from the left. Make the waves bigger close to you.*

1 *Using a conté pencil, begin by drawing a chunky rock, using small vertical strokes to suggest its surface. Place a few tiny horizontal curving lines for the moving water.*

2 *Build up the ripples around the rock, using close lines underneath the rock to suggest a broken reflection. Flick the lines on with swift movements of the pencil; don't labour the strokes or you will lose the sense of movement.*

Waterfall

To capture the sight of water rushing headlong over a waterfall, the white of the paper can be left to read as foam. An alternative approach would be to work on a coloured ground, using white conté, or pastel pencil, for the foam.

1 *Using a red-brown art pen, draw a rock, and suggest some rocks on the river bank with vertical strokes and some cross-hatching. Then, using the soft brush tip of a pale turquoise, begin to suggest the moving water, curving some of your marks down the page.*

2 *Build up more curving marks for the rushing water, together with smaller curves for the bubbles and foam at the base. Work a few strokes of pale turquoise over the rocks too.*

red–
brown

pale
turquoise

dark
green

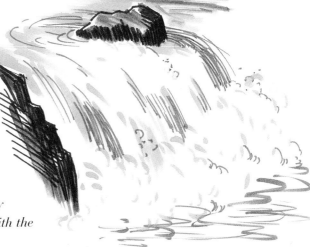

3 *Using the pen end of a dark green art pen, emphasise the rushing nature of the water with curving strokes around the rock, and down into the foam. Use some tiny dots, and arcs, in the foam, and finally, swiftly sketch in some lines at the base of the foam with the brush tip to show fast-moving water.*

EXERCISE Sketch a lake scene

Just four coloured pencils were used for this simple lake scene, which is an opportunity to practise sketching both trees and water. Try a similar sketch from life for yourself: a sketching kit of just four pencils and paper is easy to carry!

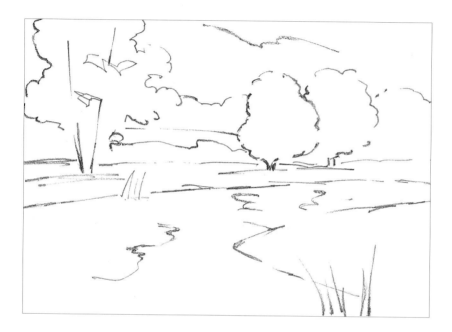

1 Using an HB pencil, lightly 'rough in' in the main elements of the scene. The pencil marks can be lifted slightly with a putty eraser once you are happy with the composition.

2 Begin with the lightest colour, a gold-yellow, and using parallel shading strokes, work across the trees, bank and land. Begin to add bottle-green.

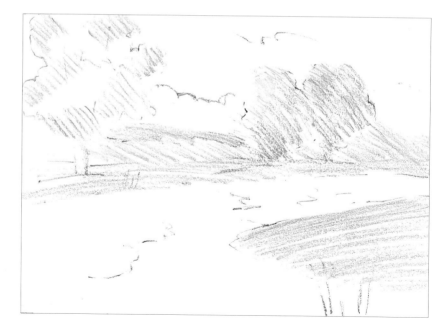

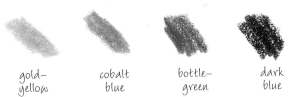

gold-
yellow

cobalt
blue

bottle-
green

dark
blue

3 *Use bottle-green for the bushes and trees, the reeds by the water, and the trees' shadows. Press hard here and there to emphasise the bank of the lake, and draw parallel horizontal lines in the water to suggest the trees' reflections. Use cobalt blue for the sky and horizontal lines on the water, reflecting the sky.*

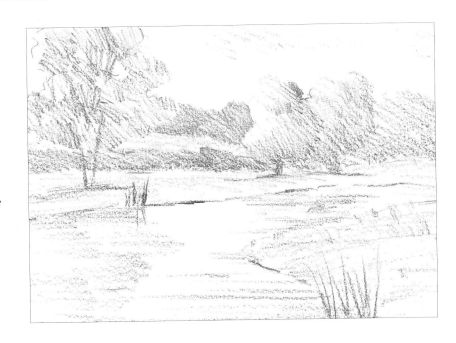

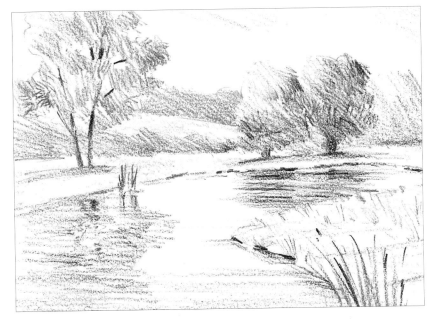

4 *Using a dark blue, and short linear strokes, darken the shadow sides of the trees on the right, the trunk and branches of the left-hand tree, and darken the tree reflections in the water. Short strokes emphasise the near bank and bring it forward, and finally, a few dark reeds finish the picture.*

LANDSCAPES

In general, when tackling a landscape, it's a good plan to consider three main areas – foreground, middle distance, and distance. If you handle these areas successfully, the viewer's eye will move back through the picture, as if walking through the landscape to the distance beyond.

Distance

To achieve a real sense of depth in a landscape sketch, you need to consider two things. Firstly, the further away, the paler things become. This is called 'atmospheric perspective'. Secondly, the further away, the smaller things become. This is an enormous simplification, but you will be successful if you observe, measure, and try to reproduce tones faithfully. It will teach you a great deal if you work in monochrome to begin with.

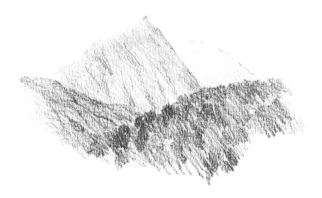

This pencil sketch of a mountain range shows how distance is implied by very pale tones furthest away, and strongest tones in the foreground. Atmospheric perspective interferes with vision, making tones lighter, less contrasting and bluer, which is why far-distant trees, hills and buildings always appear to be similar in tone, and rather blue.

This pencil sketch shows clearly that objects close to you appear to be much larger than those far away. The rocks and grasses are far bigger than the trees in the distance, and yet we know, intellectually, this cannot be the case. Always measure to double-check sizes of objects and spaces in a landscape picture.

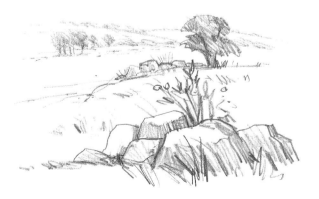

Creating depth

This little example shows how to create a sense of depth in a sketch. Use a coloured pencil
– any colour will do.

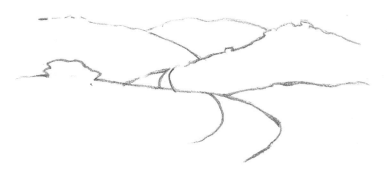

1 Begin with the main outlines in the landscape, measuring the sizes of the shapes you can see. Landscape will constantly surprise you; distant fields are often far smaller than you would think. Try to make good use of overlapping forms like these, they help to suggest space.

2 Lightly add shading over all of the distant hills, using the same tone throughout. Use a few parallel lines on the foreground.

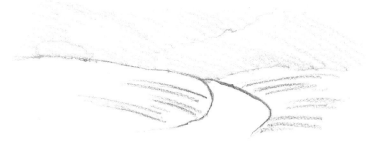

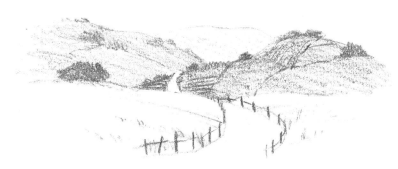

3 Build up the tone of the second and third 'hills', increasing the strength of tone gradually. Finally, draw in the details on the landscape, ensuring that the trees are larger on the nearer hill, and smaller further away. Flick in some tiny grasses in the foreground. Notice that these marks are bigger than the distant trees.

(NB If you decide to work from a photo of your own, do be careful – photos can sometimes fail to capture the subtle tones in the distance. Lighten the distance if you need to.)

Foreground

If your sketch is to include foreground, middle distance, and far distance, then a very busy foreground may prevent the eye from moving back into the picture. The problem is that the foreground will dominate our vision because it is so close to us, and the temptation to include too much is very strong. We have to learn to use what we see very selectively. Here are a few clues to the successful use of foreground features.

Roads, pathways, and river banks in the foreground will lead the eye from the edge of the picture into the middle or far distance.

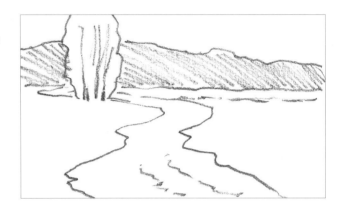

Even if there is no obvious path or edge to lead us in, we can use marks to suggest the ground surface. Here, I have used grasses, some tall enough to link foreground and background, but on a beach, for instance, it could be sand humps or pebbles, and if it was water, it could be ripples.

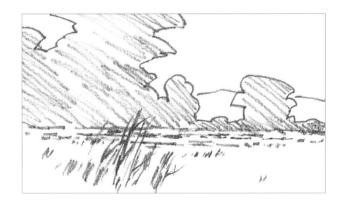

Shadows can be very useful: here they break up a flat foreground area and lead the eye back to the trees.

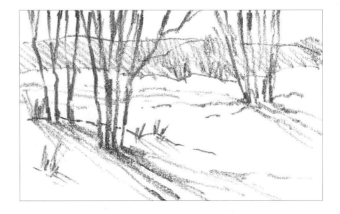

1 *Using a coloured
pencil, begin with
the main large
landscape elements in
the distance, leaving
plenty of space at the
bottom for the foreground.
Use tiny parallel strokes to depict
grasses in the middle distance.*

2 *Remember, the
closer to you,
the bigger the objects
– here the grasses and
wild flowers are taller
than the distant trees. Use
parallel strokes, dots and dashes
for the grasses, and little zig-zag
shapes for leaves and petals. In the
foreground, contrasts are strongest. Press
hard for some dark marks to contrast
strongly with the white paper.*

red orange dark
green

pale pale turquoise
blue green

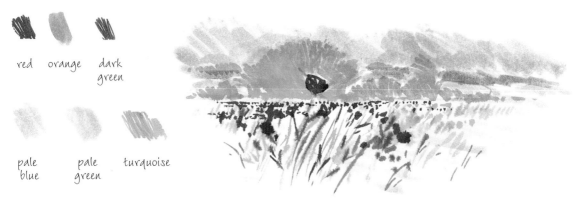

*For this sketch, I used my art pens. I began with the distance, keeping
colours light, then stroked pale green over the ground, and dissolved it
with water. While the paper was still damp, I added the foreground grasses
and flowers and, on the wet paper, some of the lines became fuzzy, which
was perfect for leaves and flowers.*

You can paint 75

DEMONSTRATION LANDSCAPE

AT A GLANCE...

1 *Working on cream-coloured watercolour paper, lightly sketch in the main elements of the landscape, using an HB pencil. You could work directly with the point of an art pen, but pencil is easier to correct.*

2 *Using the brush tip of a pale blue art pen, roughly block in the sky, and distant trees, and a few horizontal lines in the distant field. Using a pale orange pen, add some lines behind the trees, and swiftly suggest the rough foliage in the foreground and the track.*

The palette

Pastel pencils

| brown | dark grey | pale golden-yellow | dark green | grey-green | pale blue |

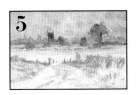 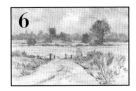

Art pens

| dark blue | pale orange | pale green | pale blue |

3 *Load a brush with clean water, and float the water over your picture. The lines of ink will dissolve, leaving you with a lovely atmospheric 'under-painting' on which to finish off your sketch.*

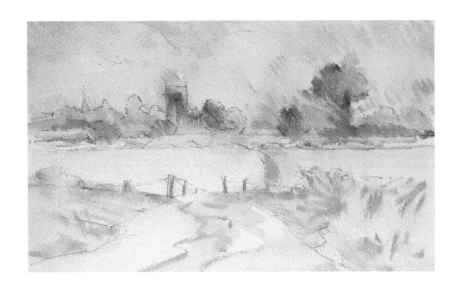

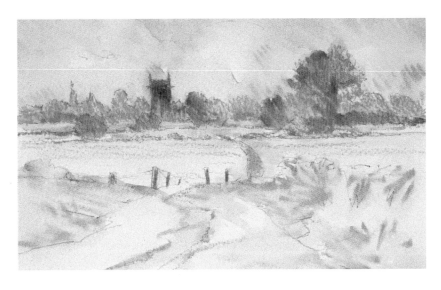

4 *When the picture is completely dry, use small strokes of a pale blue pastel pencil for the distance. Don't press too hard, then the texture of the paper will break up the marks. Very lightly stroke a few horizontal lines over the distant field.*

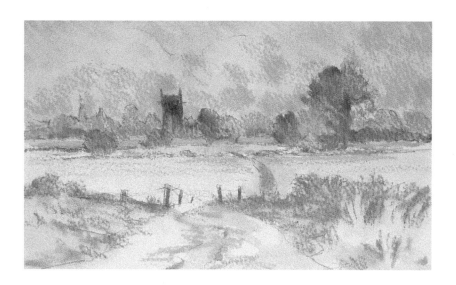

5 *With a pale golden-yellow pastel pencil,
work on the clouds behind the church, the
ground under the church, and in front of the
distant trees. With a soft grey-green, suggest
the foreground hedgerow and grasses with
little scribbles.*

*Detail: This area of
the picture shows
how well the strokes
of pastel work over
the pen brush
strokes. A mixed
media sketch.*

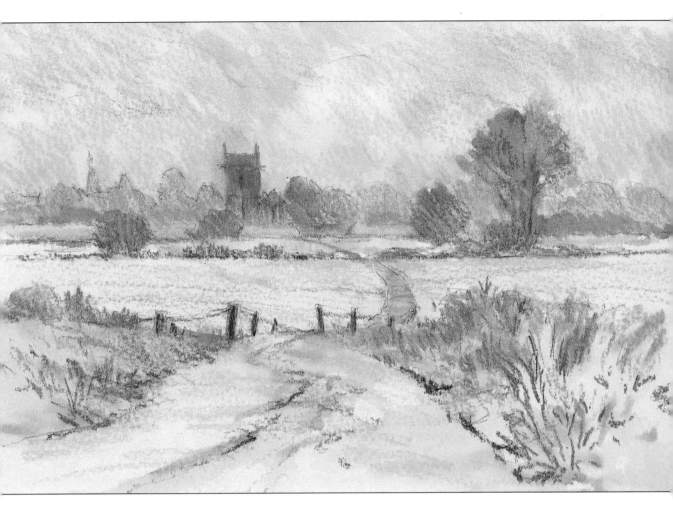

6 **Finished picture:** *Tinted watercolour paper, 18 x 25 cm (7 x 10 in). Finishing off is enjoyable, but it is easy to overdo final touches. Using a dark green, define the hedgerow a little more, with small, flicky marks. Switch to brown, and add more grasses, and go over some of the nearer trees and shrubs. Soften the colour in the clouds with more pale golden-yellow and use this colour over the road, both in the foreground and the middle distance. Finally, with dark grey, sharpen up a few foreground details – in the road, and on the fenceposts. Stop if you think you are fiddling.*

ANIMALS AND PEOPLE

A few sheep or cows in a landscape, or a cat in a garden, add life and interest to a scene, so practise sketching animals whenever you can. Be prepared for the fact that animals always move when you don't want them to – if this worries you, find sleeping creatures to sketch! Use a big sheet of paper, and if your model moves, sketch another pose, and when it moves again, start yet another. Fill the sheet with sketches, and gradually you will learn the animal's shape.

Sheep and cows

Try to simplify the shape of the animal as quickly as possible, perhaps with a basic geometric shape, and complete as much of the pose as you can. Even if the animal moves, the chances are that it will return to that pose, and you can add more details gradually.

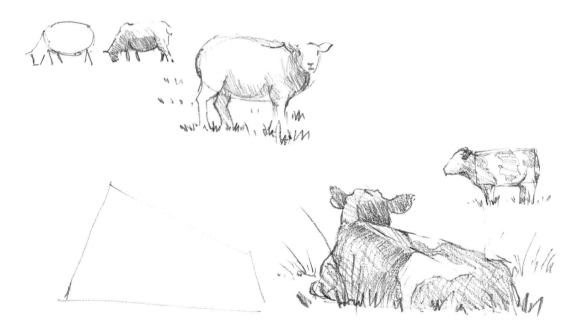

These sketches, done with a 4B pencil, show the basic geometric shapes of the animals – ovals for the sheep, and block-like shapes for the cows. Using a simple shape at the beginning will give you confidence to complete the drawing gradually.

Tortoiseshell kitten

When they have finished tearing about at top speed, kittens will collapse and sit still for quite a long time. They are lovely subjects for sketching. When they are tiny, like my Sasha, their heads seem to be too big for their little bodies.

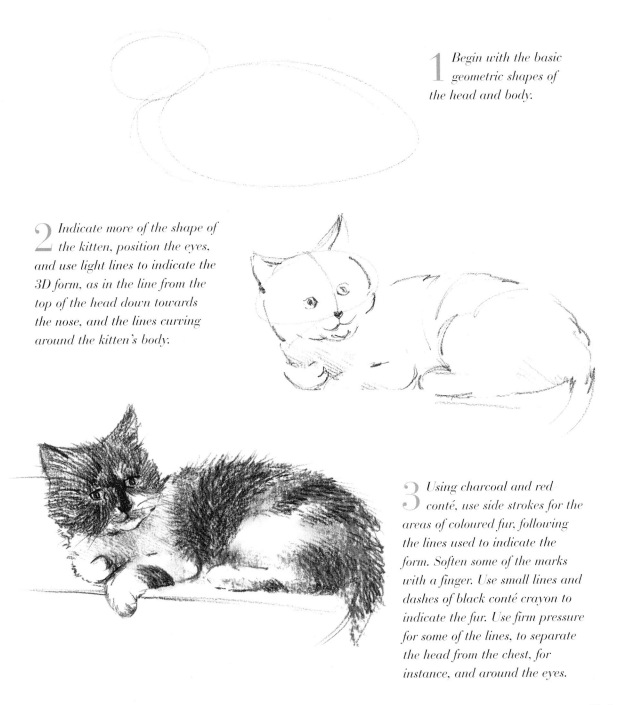

1 Begin with the basic geometric shapes of the head and body.

2 Indicate more of the shape of the kitten, position the eyes, and use light lines to indicate the 3D form, as in the line from the top of the head down towards the nose, and the lines curving around the kitten's body.

3 Using charcoal and red conté, use side strokes for the areas of coloured fur, following the lines used to indicate the form. Soften some of the marks with a finger. Use small lines and dashes of black conté crayon to indicate the fur. Use firm pressure for some of the lines, to separate the head from the chest, for instance, and around the eyes.

People

Figures can make or mar a picture. You may be able to distort a tree slightly and get away with it, but a distorted figure will look all wrong. This section is about ways to draw figures quickly and convincingly, so that you can include them in your sketches. Carry a pocket sketchbook, and practise whenever you can – in the library, while you wait at stations or airports, in cafés.

If you are unsure about how to start, pretend your figure isn't human and draw it as you would a bottle, thinking about the whole shape and the outline that contains it. The head becomes the stopper on the bottle, and the arms and legs simply part of the body of the bottle. If you get the main shape right, you will have captured the stance of the figure.

If your figure is leaning, draw the head, and a line for the feet. Draw a line from the head down the body, to show the direction of the spine. Add lines for the shoulders and hips, looking at the angle. Use your pencil as a plumb-line down the body to check angles.

Make heads smaller than you think they are. A too-large head will make your figure look like a tall child – or a figure with a balloon-like head.

Where two figures are side by side, squint to see the shape they make together, and draw that shape. Then add just enough details to show that there are two figures.

Spanish lady

I sketched this Spanish lady by her doorway. If you have time, always try to put some of the surroundings into a figure sketch. It will provide scale, and a location for your figure. A little sketch like this might prove useful one day, to include in a painting.

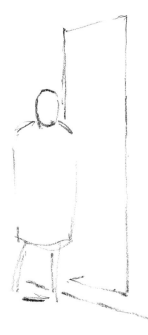

1 Begin in pencil with the main shape of the figure, the stance of the legs if they are in an unusual position, and a few lines for the doorway.

2 Add in just a little more detail – the position of the arms, and little lines to indicate the position of eyes, nose and mouth. This isn't strictly necessary, but I like to just hint at features if a figure is facing me.

3 Use coloured pencils to complete the sketch. You could keep the colours flat, without any shading if you wish – on a small sketch, this may suffice. I used the brown of her skirt for the doorway, and with this colour I also darkened her legs under her skirt to suggest shadow, and added a shadow on the ground.

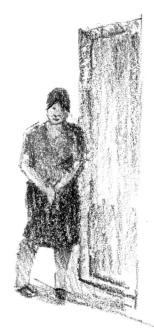

Sketch people and animals

As people, and animals, move about so much, try to develop 'speed sketches', capturing main shapes and not including fiddly details. If you copy this exercise or work from a photo, set a timer for, say, five minutes maximum, and try to work much faster than usual. This will force you to simplify.

1 *Using a 3B pencil, quickly capture the main shapes of your subject. Check proportions. This little chap's head 'goes' four times into his body (most adults are about seven 'heads' high). Unlike adults, children's heads are big in relation to their bodies.*

2 *Now define the outline of the figure more carefully. A line indicates the centre back of the head, to show that it curves, and turns a little. We look down to see a child, so the base of the T-shirt, the sleeves and the shorts arc downwards. However, on the back leg, which is lifting towards us, the lines arc upwards.*

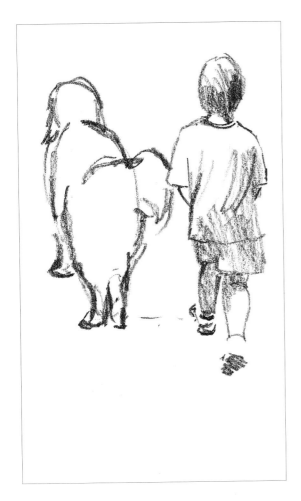

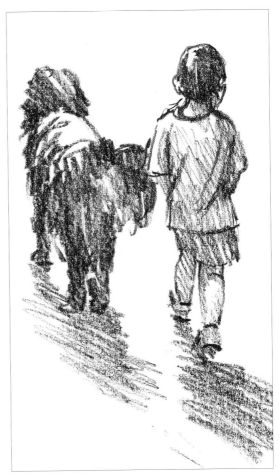

3 Refine the shape of the dog, and add some tone on the figure to explain light from above. Sketching feet can be difficult, particularly when a figure is walking or running, but just a few lines to hint at the feet may be enough.

4 Scribble is used for the shaggy dog, leaving a light area across its back to suggest its form. Add a little more shading to the boy leaving light patches on the shoulder and back calf; add shadows on the ground, then stop fiddling or you'll overdo it.

You can paint 85

BUILDINGS

Buildings, like people, need to be drawn accurately or your sketch will look very poor. Sketching buildings means tackling that supposedly frightening subject – perspective. Perspective need not be terrifying, however, provided you take on board just a few simple principles.

Basic rules

You learnt how to measure proportions on page 35. When you are using artists' measuring, don't forget to lock that elbow!

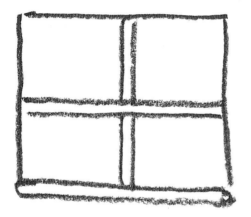

Horizontal and vertical lines in architecture are simple to draw, as in this window. You need only concern yourself with proportions.

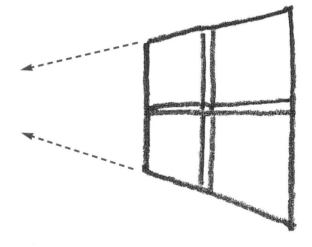

When parallel lines (the top and bottom of a window like this, or a road, or a wall) recede away from you, they create angles. If you kept on extending these lines, they would eventually meet at a 'vanishing point'. This basic rule is important to remember.

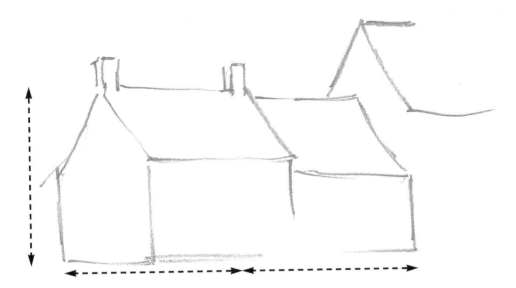

Firstly draw what you see – then check proportions. Never, ever, begin with the rules, and then try to make the drawing fit; this is a common mistake. Firstly, draw freehand, trusting your eye. Then, and only then, use perspective 'rules' to check your drawing's accuracy. Establish that the proportions of your buildings are correct. Always start with the largest proportions, and work down to the smaller ones, such as windows and doors. In my sketch, the height of the buildings 'goes' twice into the width.

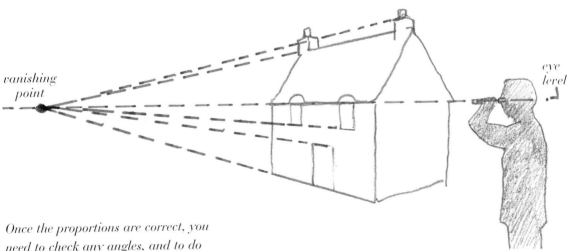

vanishing point

eye level

Once the proportions are correct, you need to check any angles, and to do this, you need to establish your eye level in the scene. Place your sketchbook on the bridge of your nose and look across it at the scene. That will be your eye level. Mark your eye level on your sketch. Now ensure that all receding lines above your eye level travel down towards the eye level, and all receding lines below your eye level travel up to it. These lines should meet at a vanishing point, which can sometimes be off the paper or sketchbook page.

Checking angles

Even if your angles meet nicely at a vanishing point, you may have misjudged them, and made them too steep or too shallow. An excellent way to check is with an angle gauge, which you can make from two pieces of card held together with a mushroom staple.

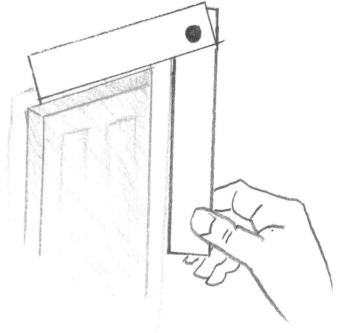

Hold the device up as if it were pressed flat against a window; line up one arm with a vertical or horizontal, and the other with the angle you wish to check. Then bring the device carefully down onto your sketchbook and check the angles in your drawing.

If you leave your angle gauge at home, you can either use a sheet of paper folded on one side to match the angle you want to check, or you can use the 'clock-face' method, imagining the angle as the time on a clock.

The shape of the sky

When you tackle a whole row of buildings, or a street scene, it can be quite difficult to simplify the mass of buildings you see, and to get the silhouette right. Try looking at the shape of the sky.

'Seeing' the sky as a simple light shape against the rooftops is a very helpful way to begin your sketch, instead of starting with the complexity of the buildings.

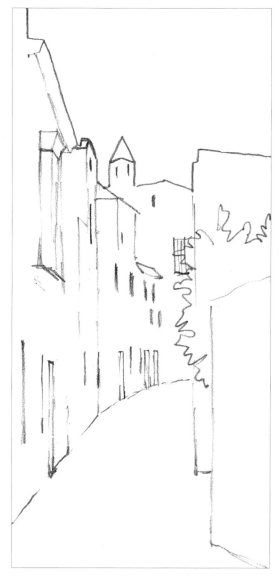

When you are satisfied with the shape of the skyline, then you can use the corners of the outline to drop down vertical lines, which will create the edges of the buildings. Then it is much easier to position doors and windows.

Sketch a street scene

I am sure that you have lots of holiday photos in a drawer. See if you can find a simple street scene to sketch like this Spanish one. Travel brochures are useful if you have no photos. After using photos, try working from life.

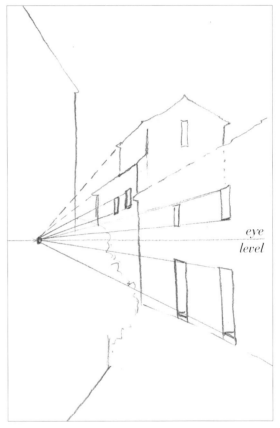

eye level

1 *In pencil, lightly draw the main outlines of the buildings and street. When you work from life, always check the shape of the sky, and the proportions of the roof shapes.*

2 *Drop down vertical lines for the edges of the buildings and lightly draw a horizontal line for your eye level. Extend the lines of the rooftops on the right, to meet at a vanishing point on the eye level. Position the windows and doors, checking to see where they come in relation to points on the roof, and each other. The angles of the tops and bottoms of the windows and doors meet at the vanishing point.*

The palette

Pastel pencils

red orange green mauve blue

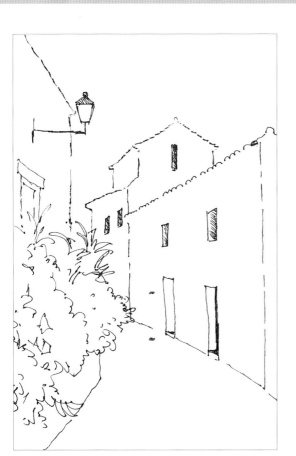

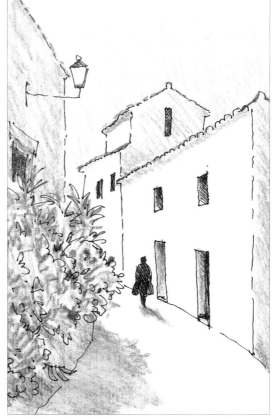

3 Switch to a black art pen or fine point pen. Draw the buildings, using broken lines, and suggest foliage on the left with scribble marks. When the pen marks are completely dry, erase the pencil construction lines. The two small dots to the left of the central doorway are there to show the position of a figure. This is a good tip – always note where a figure's head and feet lie in relation to the surroundings.

4 Quickly drop in the figure – the less you fiddle with it, the better. Don't make the head too big. Using pastel pencils, work over the pen drawing, softening the colour in places with your fingers. The purple shadows give a wonderful feeling of strong Mediterranean sunlight.

SEASIDE

The seaside is a perfect place to sketch. There are so many possible subjects – sea, shore, boats, jetties, windbreaks – the list is endless, and in the limited space of a few pages, I can only hint at the variety of fascinating possibilities.

Sea

Let's begin with the sea. Sketching waves is fun, but requires a high degree of observation and concentration. Spend at least five minutes watching the way a wave rises and tumbles over, and how it changes colour. When you begin to feel familiar with the pattern of movement, make a series of quick studies.

1 *Use horizontal strokes of bright blue watersoluble pencil for the distant horizon and sea, and curving strokes for the breaking wave. Block in the water behind the wave, leaving gaps to represent more distant waves. Use a light yellow-green for the top and 'inside' of the wave, and blue for its shadow.*

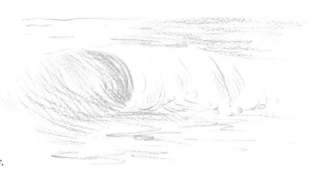

bright
blue

yellow-
green

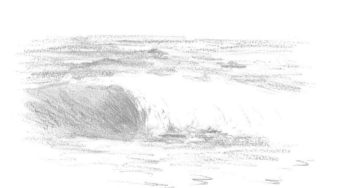

2 *With a wet brush, 'loosen' the colour. While the paper is wet, you can add more blue pencil if you have lifted too much colour. When the paper is dry, use a craft knife to scratch the paper to create a few bubbles on the edge of the wave, and for a few 'white caps'.*

Rocks

Rocks on the beach will often have quite complex shapes, having been battered by the elements for ages. By squinting, you can simplify their shapes into simple blocks. Always begin with the main, large shape, and add details, such as cracks and textures, last.

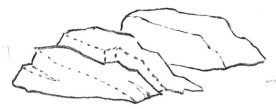

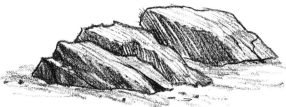

1 *Using sanguine conté, lightly sketch the outline of the rocks, and include some suggestion of their blocky shapes, using a line to show where there is a change of plane. It helps to squint, to simplify the rock's shape.*

2 *If light strikes the top of the rocks, then the side planes will receive less light. Use linear strokes of conté, building up a heavier concentration of strokes on the darker sides of the rocks, and add details, such as cracks.*

Boats

Boats can be tricky to draw, since they bob about on water, tilt on land, and have complicated curving shapes with strange bulges. Always check proportions properly, and study shapes carefully. Choose simple shapes first, and move on to boats with masts, rigging and other paraphernalia.

1 *Draw a simple rowing boat with a pencil, freehand. Now check the tilt of the boat. Look at my red dotted line, and see how the prow is lower than the stern.*

2 *Begin to improve the drawing, adding tonal shading for the bulge of the hull. Add details gradually. Make the nearest edge firmer than the distant edge, to bring it forward. The shadows inside the boat are the darkest marks.*

DEMONSTRATION A BEACH WALK

AT A GLANCE...

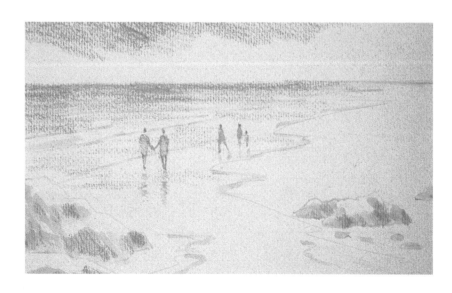

1 On blue-grey pastel paper, draw the scene with an art pen. Use the brush tip to block in the darker sides of the rocks and add horizontal strokes for the sea. The people's heads are all in line (except the child). Try to get their proportions right.

2 Switch to pastel pencils, and scribble in some blue for the sky, and some horizontal strokes for the sea. Also, put some blue onto the darker sides of the rocks. We are going to build up the rocks with lots of different colours, to make them interesting.

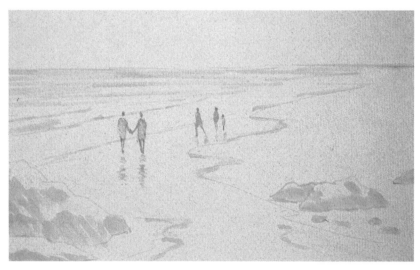

The palette

Pastel pencils

white orange- pale raw orange
 pink yellow sienna

pale dark blue
grey grey

Art
pen

blue

3 *Use yellow and raw sienna for the sand. Wet sand is darker than dry sand. In the fore-ground, separate your strokes a little to suggest undula-tions in the surface. In the distance, use sweeping horizontal strokes which blend together naturally.*

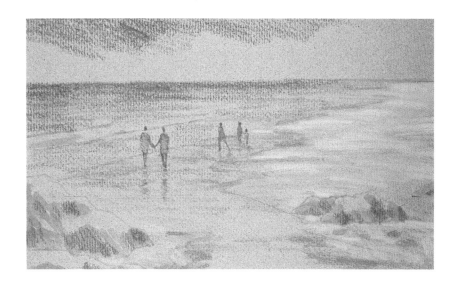

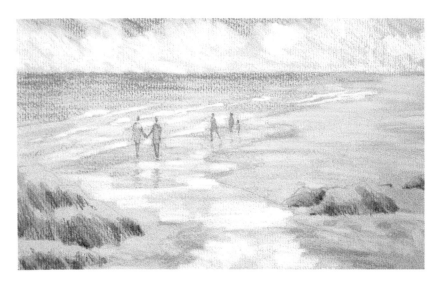

4 *Use white for the clouds, wave edges, and water on the sand, pressing hard where the clouds are reflected. Change the direction of your strokes in the clouds for a lively effect. Use dark grey and a little raw sienna on the darker sides of the rocks.*

5 *Tiny strokes of colour indicate the people's clothes, and use the same colours with small horizontal, broken strokes for reflections. Use dark grey for the heads. Work more detail into the rocks with pale grey.*

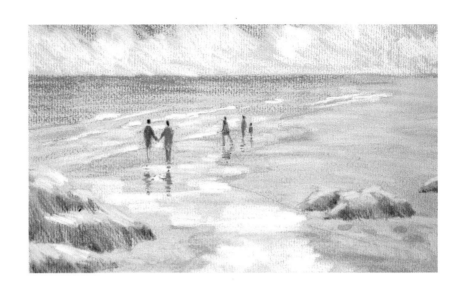

6 **Finished picture:** *Pastel paper, 15 x 23 cm (6 x 9 in). Add a few dark grey pebbles, with a touch of a lighter colour on the top. Stroke a little blue at the base of the rocks for* shadows; suggest a few cracks in the rocks with dark grey and add a few strokes of orange-pink to the sand. Finally, break up the people's reflections slightly with a few horizontal strokes.*

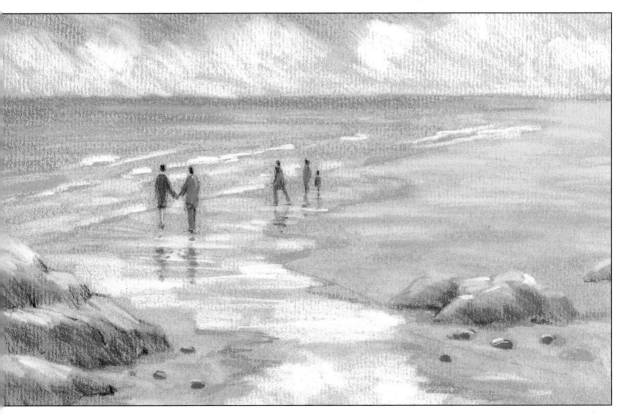